THE BOOK OF KIMONO

THE BOOK OF
KIMONO

Norio Yamanaka

KODANSHA INTERNATIONAL
Tokyo and New York

Kimono made by Chikichi (p. 20), Chiyoda no Kimono (pp. 14–15), Mimatsu (p. 17), Marumiya (p. 13), Sagami (p. 19), Suzunoya (p. 16) and Sōdō Kimono Academy.

Color photos by Ken'ichirō Ōyama (p. 18) and Sōdō Kimono Academy. Black and white photos by Hideo Oda, Hishiichi, Seibu Department Store and Sōdō Kimono Academy.

Distributed in the United States by Kodansha International/USA Ltd., 114 Fifth Avenue, New York, New York 10011.

Published by Kodansha International Ltd., 2–2 Otowa 1-chome, Bunkyo-ku, Tokyo 112 and Kodansha International/USA Ltd., 114 Fifth Avenue, New York, New York 10011.

Copyright © 1982 by Kodansha International Ltd.
All rights reserved. Printed in Japan.
First paperback edition, 1986
Third printing, 1989

ISBN 0–87011–785–8
ISBN 4–7700–1285–3 (in Japan)

Library of Congress Cataloging in Publication Data
Yamanaka, Norio, 1928–
 The book of kimono.
 Includes index.
1. Kimono. 2. Obi. I. Title.
GT1560. Y26 1986

Contents

Note: Metric measurements are used throughout this book. 2.5 cm. equal 1 in; 30.5 cm. equal 1 ft; 91.4 cm. equal 1 yd.

Introduction

Among the many comparisons made between Japanese and western culture, one of the most famous is Ruth Benedict's description of the West as a "guilt" culture and Japan as a "shame" culture. While *shame* may do well enough as a catchword, my own belief is that if we delve further we will find that Japanese society highly values the appreciation and cultivation of respect for the "other," a respect not only for other people, but for the environment in which we live. It is this unselfish sensitivity to things and beings in nature that best describes the essence of Japanese culture.

This is important in understanding the role of the kimono in Japanese culture, as is the idea of the West as a *suru bunka*, a "culture that does" things, and Japan as a *naru bunka*, a "culture" in which things "become." Western culture has had as its basis the absolute principles of Christianity and its goals are calculated and deliberate. Utilitarian goals are not unknown in modern Japan, which is the result of a cultural development very different from that of the West, but historically of much greater importance was the establishment of a vibrant relationship with nature. It is a culture that prizes love, admires beauty, respects courtesy and fosters harmony.

To make it comfortable during the hot humid summers, the Japanese house has long been constructed in an open flexible style. Houses were built to harmonize with land and climate, and the same is true of Japanese dress. Since prehistoric times, the Japanese style of dress has been essentially two pieces of cloth, sewn together back and front and held in place with a cord or sash tied at the waist. At an early stage there were separate upper and lower garments, but over time the kimono became a single garment with wide sleeves and of an ample length and size to make it airy and comfortable for summer wear. To keep warm in winter, it was only necessary to put on more layers of kimono.

This "wrapping" phenomenon, a distinctive aspect of Japanese culture, was seen most dramatically during the Heian period (794–1185) when ladies of the court donned twelve layers (*jūni-hitoe*) of kimono for ceremonial occasions. From

7

this arose a unique and deep appreciation of colors and their combinations, for great care was taken in matching and harmonizing the colors of the kimono. Some two hundred rules were established governing such things as the combination of the colors of the kimono collars and how the colors of the outside and the lining should be harmonized. Even today the accepted kimono colors for the months from November to February are referred to by the traditional term *ume-gasane*, "shades of the plum blossom," a kimono which is white on the outside and red on the inside. For March and April there is the combination called *fuji-gasane*, "shades of wisteria," a kimono with lavender outside and a blue lining. Other names include *beni hitoe*, a red unlined summer kimono; *ura yamabuki no uwagi*, an outer garment of yellow and orange for winter and spring; and *matsu-gasane*, "shades of pine."

Choosing colors to mirror the seasons and their moods is a reflection of how the Japanese became finely attuned to even the slightest change in the seasons and learned to appreciate the beauty of things in nature. This preservation of tradition in the world of kimono is being carried into the future, for with the development of advanced techniques in textiles and design this color sense finds more varied and interesting expression.

A close connection with nature exists too in the vegetable dyes and patterns and designs of kimono textiles. No one would think of putting on a kimono with cherry blossom designs in the winter or fall. Cherry blossoms are a spring design and should be worn when they are in full bloom. For winter one might choose snow scenes or plum blossoms. Representative summer and fall designs are ocean waves and red maple leaves. Whatever the season, the ability to wear a kimono that reflects its colors and mood has always been considered the mark of a truly sensitive person.

Yet another seasonal tie is the custom of putting away and bringing out kimono (*koromogae*) in conjunction with the beginning of summer and the onset of winter. This became an official semiannual observance during the reign of Emperor Go-Daigo (1318–39), and people changed not only their style of dress, but all aspects of their lives both indoors and out. This courtly custom filtered down to other classes, and by the Meiji period (1868–1912) had become one observed by almost all Japanese. Almost as if a person were reminding nature of the time for a change, the custom was a reflection of one's desire to demonstrate the depth and sincerity of his sensitivity to the seasons, nature and life. With the coming of modern heating devices and air conditioning, the custom is no longer strictly observed, but it still serves to remind us of the seasonal and spiritual changes that occur in a human being's life. For those devoted to the kimono, it is what I have chosen to call the wisdom of harmony.

The literal meaning of *kimono* is a "thing," *mono*, "to wear," *ki(ru)*. If we keep this in mind and ask how does a person who wears a kimono "become," we can better understand the meaning of this attire which embodies in a variety of ways the heart of the Japanese and their culture. Although artistically and technically one of the most exquisite national costumes in the world, the kimono radiates its true beauty only when worn, and it is at the moment it is put on that the wearer begins to feel fortunate.

At the mention of kimono, our minds immediately tend to make a distinction between Japanese and western styles of clothing. And people hear the word *kimono* and imagine "something beautiful" but rarely appreciate the physical and spiritual transformations that occur in the wearer of the kimono. In truth the very act of putting a thing on joins that thing to human life and gives it form.

Although western style clothes, whether ready-made or tailor-made, come in a great variety of forms and designs and sizes, the form is fixed before the garment is put on. Thus, the garment either fits a particular person or it does not. Quite the opposite is true of kimono, since from the most formal to the most casual they all have the same form. If a kimono is taken apart, it can be resewn into the shape of the one piece of material it originally was. It is possible to speak of the true form of a kimono only after it has been put on a human body. In other words it is the wearer who, according to his proficiency, creates the form. It is this potential to highlight and express a person's personality that makes kimono so different from western styles of dress.

To look at it another way, it can be said that devotion to the kimono has played an important role in the formation of Japanese culture, for this culture has been molded equally from the crystallization of the spirit and the life style of wearing the kimono. This wisdom of our ancestors has been inherited and exists today.

Since it is what is inside that gives the kimono its true form, it is meaningless for the wearer to merely imitate another person's outer or physical presence. Those who would make the beauty of the kimono their own must first make their own spirit and character a thing of beauty. This is the wisdom of beauty for those devoted to the kimono.

What is true of the kimono is true of the obi. "An expression of beauty fastened to a woman's back," as it has often been described, it must be remembered that only in the act of tieing the obi, giving it its true form, does its real significance become apparent.

Historically there existed a belief in the magical power of tieing things, which was equated with the establishment of a connection. It was believed possible to transfer one's love or spirit

through the tied knot, and if the strands of the knot were well unified, a new value could be created, just as a new value, a child, is created through the union of man and woman. From very early times people exchanged knots of love or knots to act as amulets to ward off evil or injury. *Musubi*, the word for "knot," was sometimes written with the Chinese characters meaning "living spirit," and the knot was regarded as indeed being the resting place of the soul. The sincerity of this belief can be seen in a poem from the *Man'yōshū*, the earliest (eighth century) and longest anthology of Japanese poetry:

> *This kimono sash my wife has tied,*
> *Never by my own hands will be undone.*
> *Though the sash be completely severed*
> *I'll not untie the knot, till I see her again.*

Both kimono and obi emphasize the beauty of straight lines. When the kimono is worn, the lines are free falling. When the kimono is folded to be put away, the flowing lines are in a sense preserved by folding along the vertical seams. Making the folds straight and correct (*orime tadashisa*) evinces the good manners of the wearer. To those devoted to the kimono this is the wisdom of courtesy.

Shitsuke, "basting," is another word suggestive of the influence of the kimono on Japanese culture as a whole, for its homonym *shitsuke* means disciplining, especially children, and training in proper manners and behavior. Similarly, from the expression "to arrange (kimono) collars" (*eri o awaseru*), we have the phrase *eri o tadasu*, meaning to straighten one's posture. From these examples we can perceive the practical lessons the kimono has to impart, which heighten our spiritual appreciation of all the things that make life possible.

The kimono is sewn along straight lines, making it possible to take apart and resew the same kimono any number of times, and people have customarily endeavored to wear kimono and handle them with the utmost care. Because of this and the strong personal connection with particular kimono, people naturally desire to hand them on to their grandchildren. This is possible, but it depends on the spirit of the person who wears the kimono. Then, too, if there is no one to carry them on, customs and traditions will be lost.

Today, it would seem, the majority of Japanese regard the kimono as a ceremonial costume to be worn, at most, two or three times a year, and for the younger generation the kimono is little more than a relic of old Japan having no connection with their daily life.

The reasons are not hard to trace. After the isolation of the Edo period (1603–1868), foreign products and ideas began to enter Japan again. The flow of things western was like a flood, and western clothes made an almost immediate impact on the

traditional Japanese style of dress. But while men, especially, changed from the kimono to western style clothes, the kimono did remain the most popular style of dress for women. With the coming of the Second World War, this also changed. In fact, because of wartime shortages the wearing of kimono almost ceased, and after the war, as people sought to imitate and develop a western life-style, the preference for western clothes became very strong, noticeably among those who grew up during the war and had no knowledge of how to put on a kimono and no training in the proper way to move and act in a kimono.

In effect, a gap has appeared between the kimono and the people who would wear it. This is not to say that the kimono is not admired. In numerous surveys in recent years, responses have been very positive. People speak of how they are attracted to the kimono, of how they would welcome the chance to wear one, and of how they would like to become the kind of person who looks good in a kimono. On the other hand I can think of nine reasons women give for not actually wearing kimono. They say they do not know the traditional value of the kimono, nor how to appreciate and enjoy wearing one. They say they cannot sew a kimono, nor do they know how to choose the right one. Because the kimono is expensive, they say they cannot afford one. They say they cannot put on a kimono alone, nor do they have anyone to teach them about kimono. Some say they have no place to wear a kimono, and some say they do not have room to store one.

My belief is that if the kimono becomes estranged from our daily life, we will lose something precious, in the care needed to put a kimono on, in the manners and movements appropriate to the one who wears it, and in the sensitivity to life and nature the kimono fosters. That is why I have begun to search for ways to revive popular interest in the kimono, not simply as a fashionable style of dress, but as a way to make us more aware of our subtle relationships with the things we wear.

A number of tasks remain to reestablish the kimono in today's fashion world. While natural kimono fabrics (silk, cotton, linen, wool) and hand-made textiles and patterns remain the most highly valued, it is also true that the improvement of synthetic fabrics has made the kimono more affordable, and a wide variety of new dyed and woven patterns are now possible. Along with kimono makers, who have focused their attention on making the kimono easier to wear and more suitable to modern life styles, I myself have invented and developed many devices to help people put on the kimono and tie the obi. One result of these efforts is the *tanosic* kimono, which may be called a "world garment" in that it can be worn either as a kimono or as a western style dress and which I introduced at my lectures at the United Nations in 1980 and 1982.

While taking advantage of the fruits of technical virtuosity,

we must not neglect the spiritual foundation of kimono culture: love, beauty, courtesy and harmony. For these are at the heart of the matter, if we are to renew our concern for the ways we care for the things we wear and become more sensitive to the needs of others. These are qualities we will need in the world of the future, as we repeatedly confront the problems of dwindling resources and energy reserves.

The kimono can have meaning in other countries, where its beauty has already been recognized, as well as in Japan. Just as there is a *dō*, a "way," in the practice of the tea ceremony and in flower arranging, I believe there is a "way" in wearing the kimono and that understanding this way will lead to a rediscovery of traditional cultural values.

This was my philosophy when the Sōdō Kimono Academy was founded two decades ago, and since 1970 I have annually sent delegations of "kimono ambassadors" to foreign countries. These delegations, each of more than one hundred members, have given kimono shows and demonstrations in major cities, and the work of the Sōdō organization is becoming known in international circles. I have given this activity my wholehearted support, believing firmly in the importance of international understanding and being confident that in this confused and troubled age people can come to realize the spiritual connections between themselves and the things they wear.

As the number of people wearing kimono grows, both in Japan and in other countries, the spirit of kimono culture will deepen. Through the repetition of wearing kimono every day, even such a simple thing as common sense will be enhanced. It is my conviction that, in essence, this is the key to the achievement of peace and well-being throughout the world.

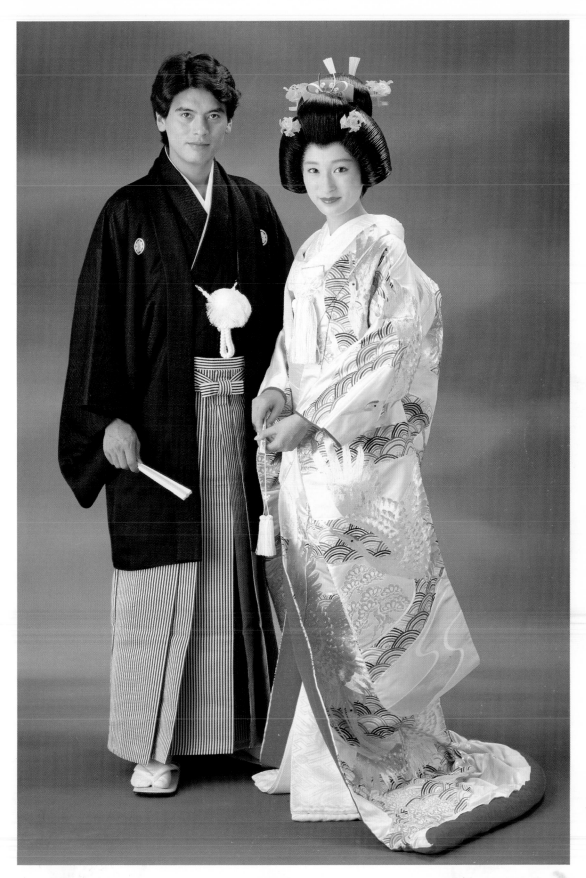

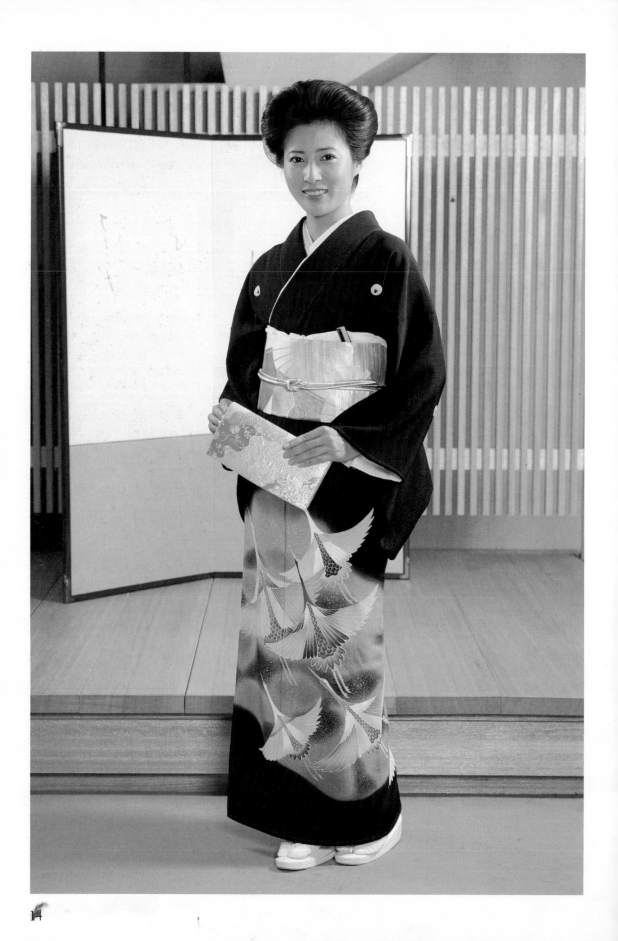

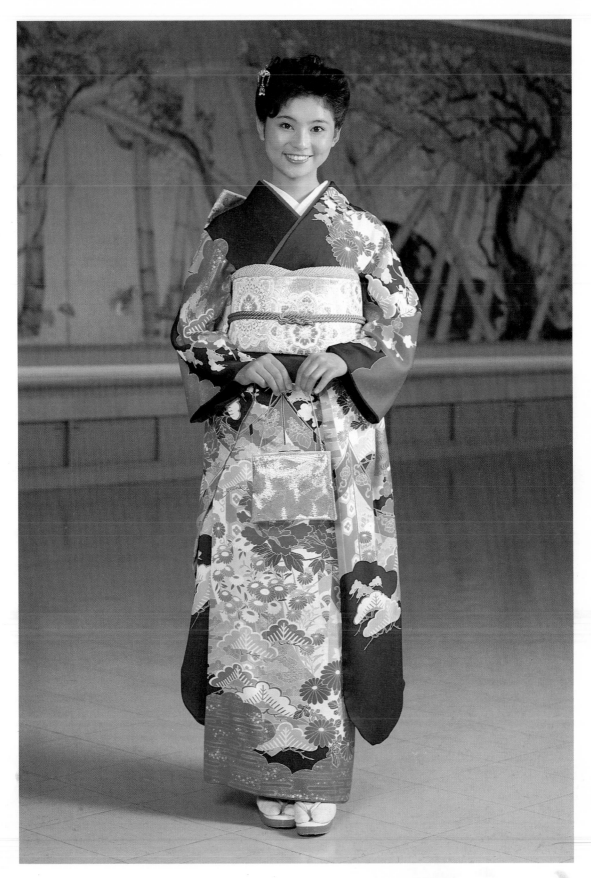

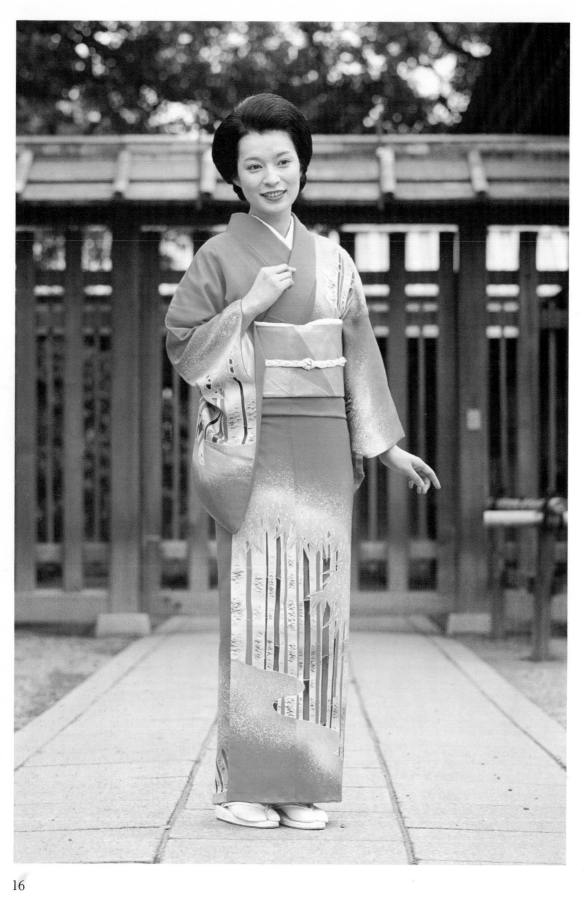

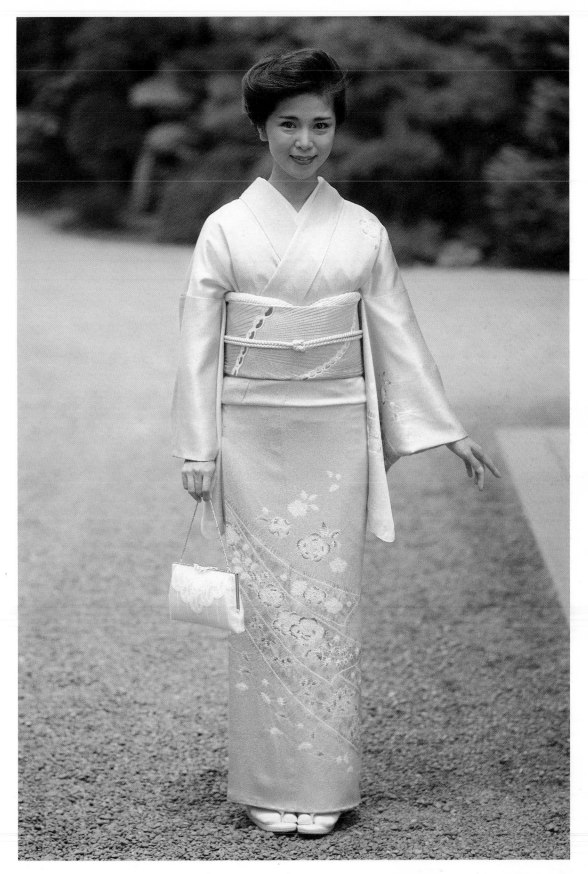

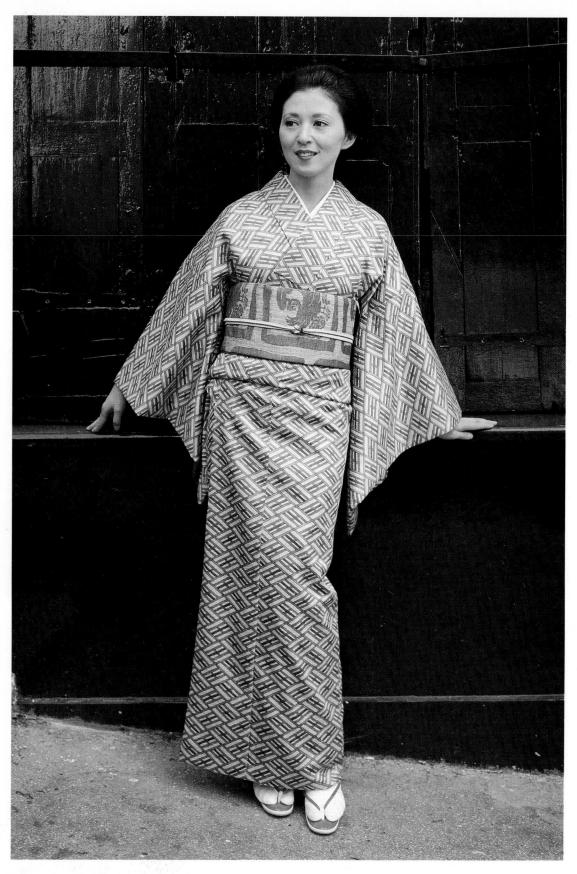

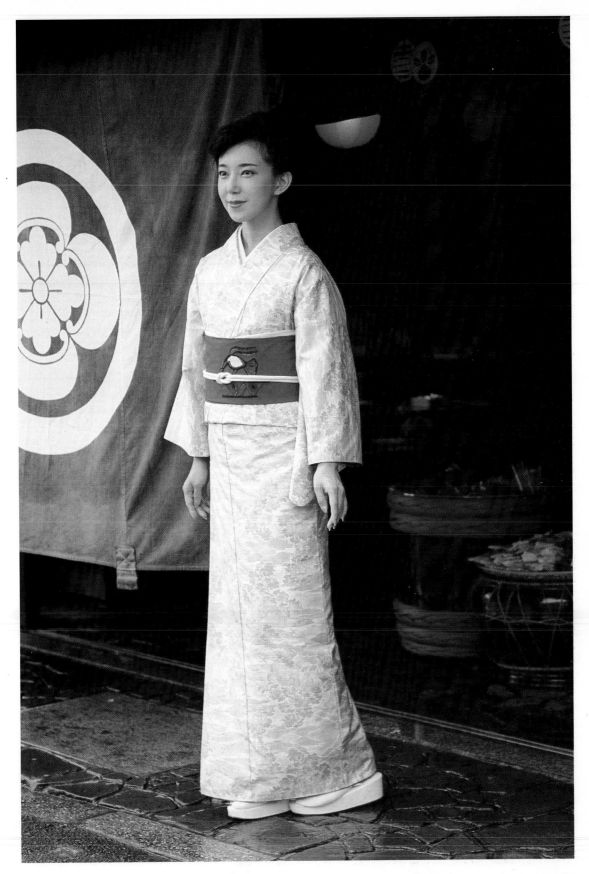

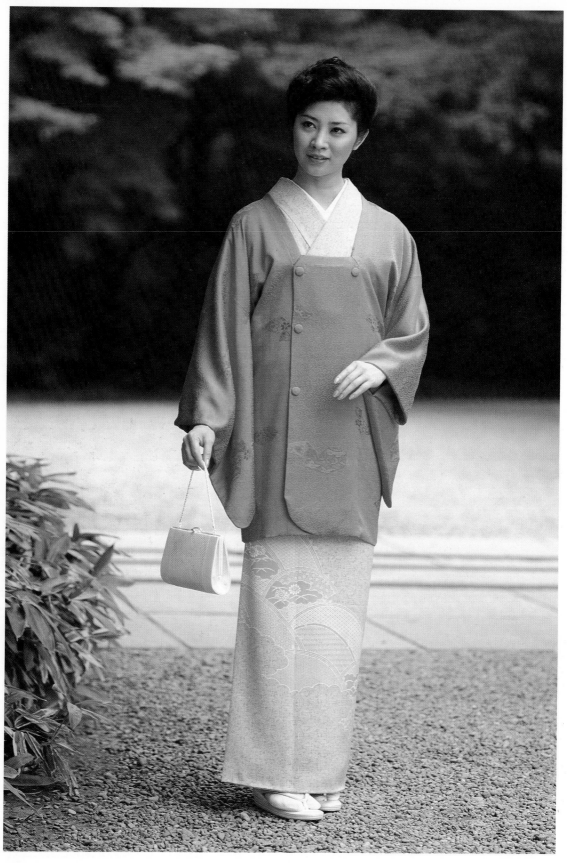

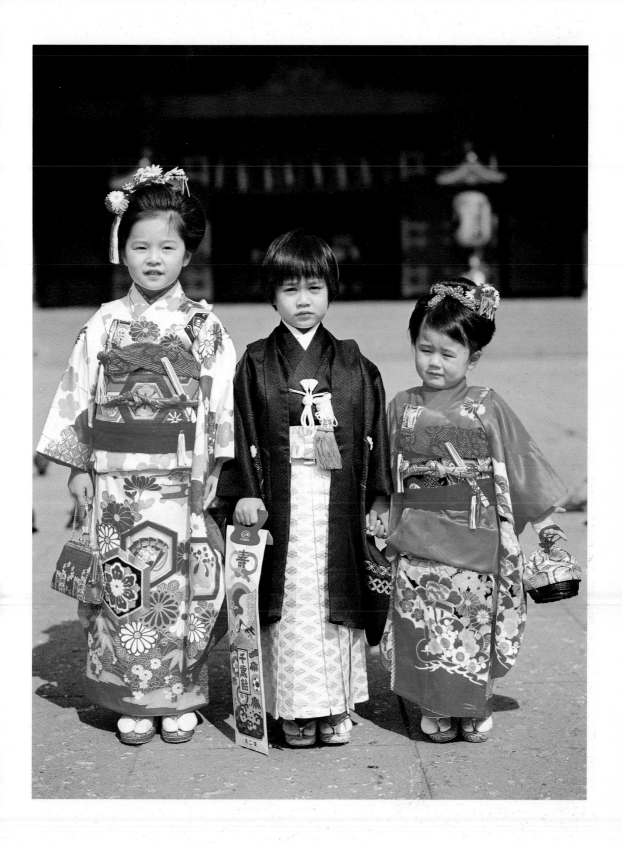

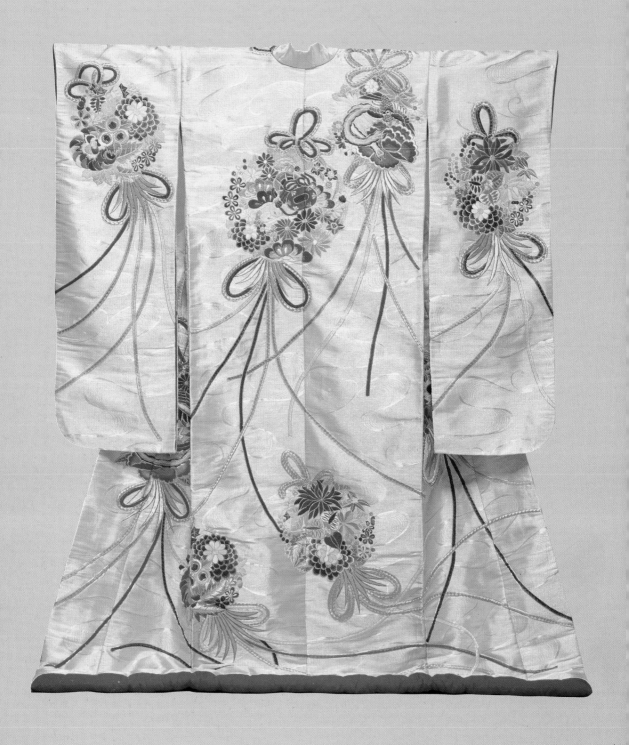

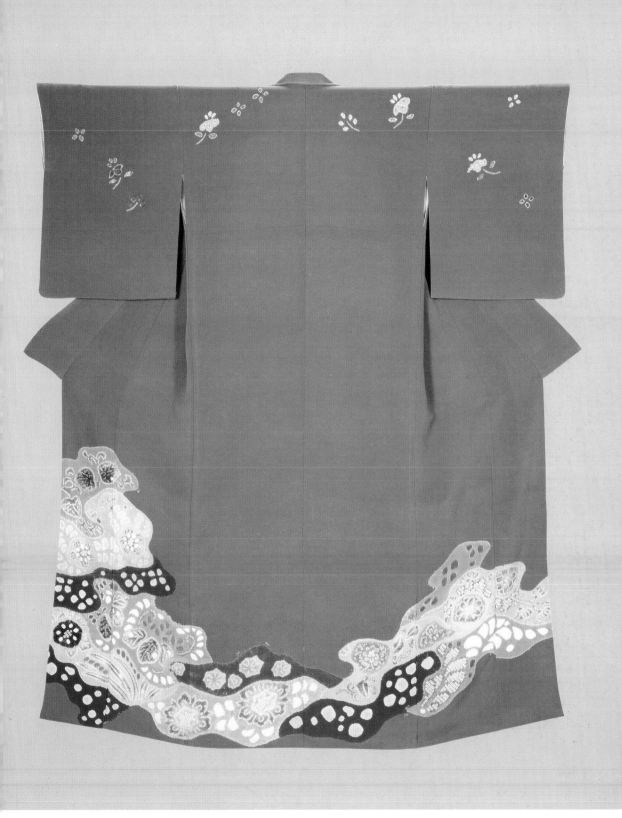

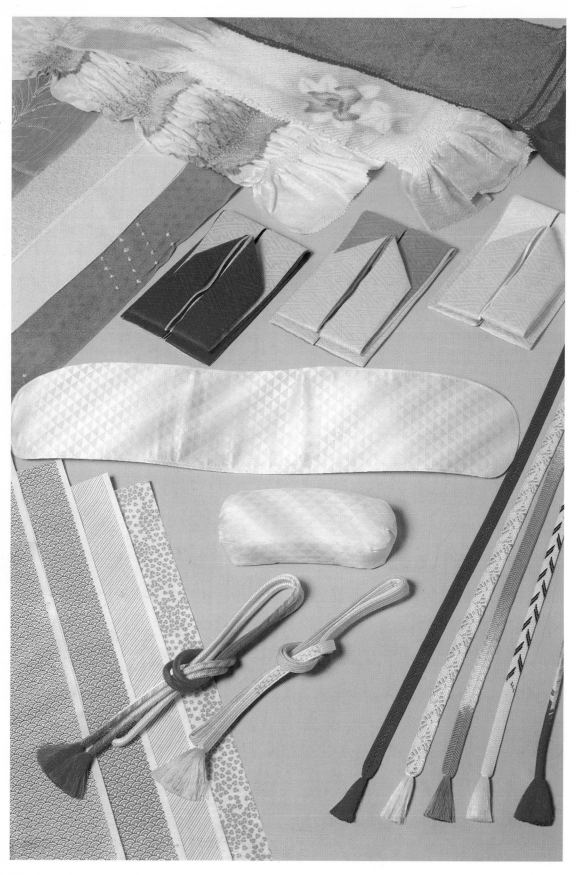

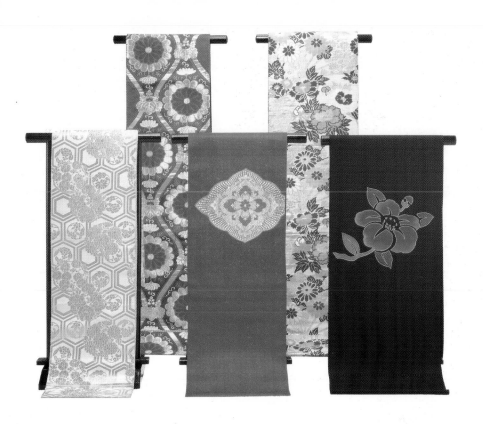

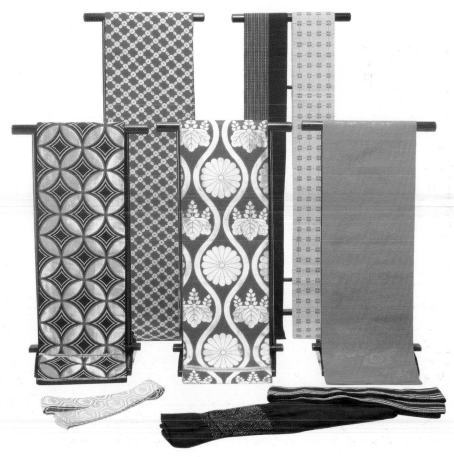

1.

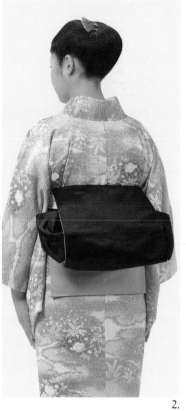

2.

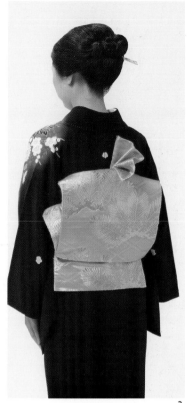

3.

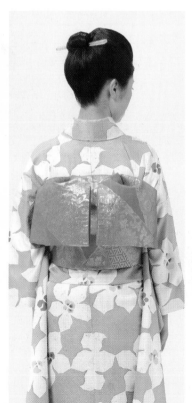

4.

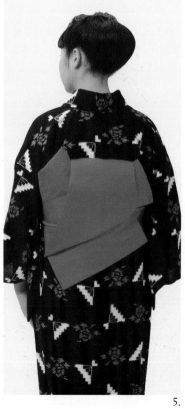

5.

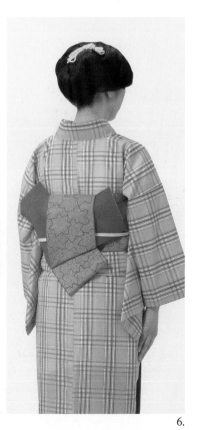

6.

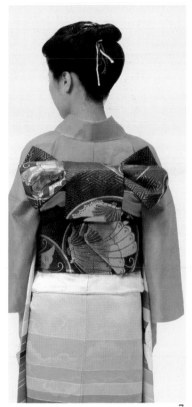

7.

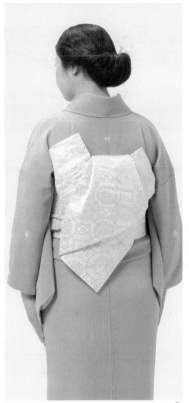

8.

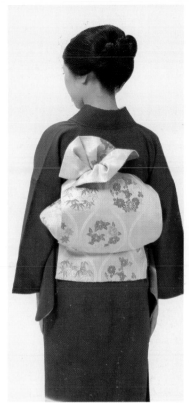

9.

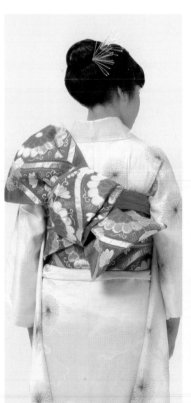

10.

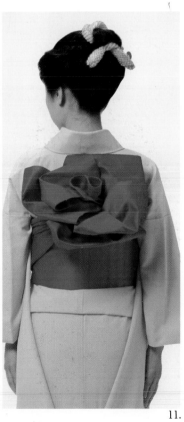

11.

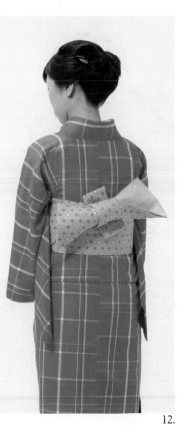

12.

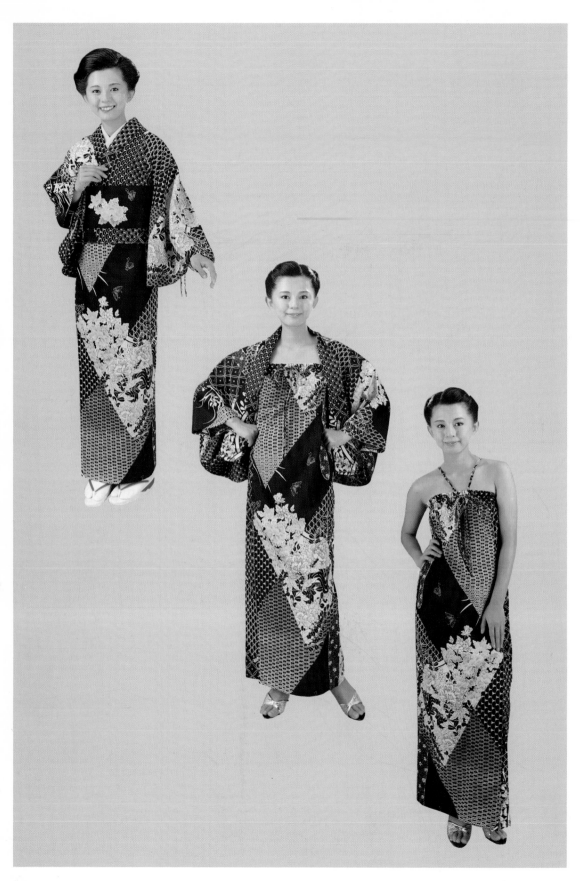

28

COLOR PLATES

p. 13. The groom is dressed in the most formal attire for men: white under-kimono, black kimono, five crested *haori* with white *haori* cords, *hakama* of Sendai *hira* silk, white *tabi*, and *zōri* with white straps. The bride wears the *uchikake* robe over the *kakeshita* kimono. The *uchikake* pattern of cranes, waves and pines is for felicitous occasions.

p. 14. The *kuro* (black) *tomesode* with five crests is the most formal kimono for married women. The purse has been chosen to match the double-fold obi with its gold and silver fan design.

p. 15. The brightly colored *chūburisode* is formal attire for single women. The seasonal pattern includes peonies, chrysanthemums and pines.

p. 16. This visiting kimono (*hōmongi*) for married women has a bamboo grove pattern.

p. 17. The *tsukesage* pattern of this kimono seems to rise from the hemline. Bustle sash and obi cord harmonize with the gold patterned obi.

p. 18. *Komon* (small designs) repeat a diamond shape. The spun silk obi has an abstract design derived from the Chinese phoenix.

p. 19. A favorite kimono fabric is the very comfortable and famous Ōshima *tsumugi*.

p. 20. The short *michiyuki* coat, with its squarish *michiyuki* collar, is the most commonly worn kimono coat.

p. 21. These children are dressed up for the celebration of *Shichigosan*. The girls wear very colorful Yūzen kimono and sandals of gold brocade. The boy's crested *haori* perfectly matches his kimono, which is worn with a patterned *hakama*.

p. 22. In this ceremonial *uchikake* kimono, lines are woven into the background with gold thread. The embroidered design is of flowered decorative paper balls.

p. 23. This contemporary Kaga Yūzen kimono has a traditional Tsuji-gahana pattern. The small motifs at the top and the roundish parts of the bottom pattern are tie-dyed.

p. 24. Kimono accessories. *Upper left and top*: obi-*age* (bustle sashes). Below these are three *date eri* (detachable collars). *Right and bottom center*: obi-*jime* (obi cords). *Lower left*: han eri (half collar). Center: Obi *ita* (obi stay), below which is an obi *makura* (obi pad).

p. 25. Obi. (Top photo.) *Upper row, left to right*: fukuro (double-fold) obi. *Maru* obi. *Lower row, left to right*: kakeshita obi. Double-fold Nagoya obi. Nagoya obi.

(Bottom photo.) *Upper row, left to right*: lined *haraawase* obi. Unlined *hitoe* obi. *Middle row, left to right*: iwai obi for felicitous occasions. *Odori* (dance) obi. *Bottom row, left to right*: kakae obi, a narrow patterned obi worn by young girls or as a decorative accent with bridal kimono. The soft *heko* obi and stiff *kaku* obi for men.

p. 26 1. *Hinode-daiko musubi*, sunrise drum bow for ceremonial and for-
−27. mal wear. This bow tied with the double-fold obi is suitable for young married women.

2. *Tsuno-dashi-daiko musubi*, drum bow with horns for visiting or in-town wear. This is a very stylish way to tie the Nagoya obi.

3. *Ōgi-daiko musubi*, drum bow with fan for ceremonial and formal wear. Young married women tie this elegant bow with the double-fold obi.

4. *Bunko musubi*, box bow for visiting or in-town wear. This is a dressy bow tied with patterned or patternless Nagoya obi or double-fold Nagoya obi.

5. *Kai no kuchi musubi*, shellfish bow for visiting or in-town wear. Both single and married women tie the Nagoya obi in this nice sharp bow.

6. *Ya no ji musubi*, arrow bow for everyday wear. Married women find this bow convenient when wearing a *haori* or when at home.

7. *Ichi monji bunko musubi*, straight line box bow for ceremonial and formal wear. The most representative of box bows, it is very becoming with the modern single woman's formal kimono.

8. *Chidori musubi*, plover bow for ceremonial and formal wear. This way of tieing the double-fold obi gives a feeling of crispness and is popular with both younger and older women.

9. *Fukuju so musubi*, Amur adonis bow for ceremonial and formal wear. A bow with a youthful look, it goes very well with New Years' kimono.

10. *Tateya musubi*, standing arrow bow for bridal wear. This traditional *maru* obi bow conveys a feeling of composure and dignity and is the most appropriate bow to be worn with the *honburisode* kimono.

11. *Bara musubi*. The rose bow is one of many seasonal bows whose shapes resemble flowers. An obi of the same color as the flower is used. The month for the rose bow is May, when young women tie it to go with the *furisode* kimono.

12. *Bunko-gaeshi musubi*, reverse box bow for everyday wear. A very efficacious and pleasing way of tieing the half-width obi, it can be worn by girls in their teens or young single women.

p. 28. A recent development in kimono wear is the *tanosic*. By attaching the inner collar to the upper garment and putting on the obi, it can be worn as a kimono for outings and traveling (*upper left*). With the inner collar and obi removed and the collar of the upper garment turned up, the *tanosic* becomes a long gown with a *happi*-style coat (*center*). At home the lower garment can be worn alone, using the strap attached to the inside of the shirring at the bosom (*lower right*).

A Brief History

From Neolithic Times to the Present

Tracing the origins of Japanese dress is largely a matter of conjecture, since the earliest fragments of Japanese textiles that have been preserved date from the Asuka period (552–646). However, on the basis of archaeological excavation, two very distinct types of Neolithic culture have been recognized. They are distinguished by the differences in their pottery-making techniques and designs.

The prehistoric Jōmon period lasted several thousand years, ending in the third century B.C. The heavy earthenware pots of this period were made with coils of clay and are characterized by their highly varied decorative designs, which are artistically superior to those of other Stone Age cultures. The designs probably derived from basket-weaving, the techniques of which were also highly advanced for the time, and fine mat designs impressed on the surface of many pots clearly point to the presence of carefully woven cloth. Still, although cloth fragments from the early periods have recently been discovered in Miyagi Prefecture, very little is as yet known about how the earliest Japanese dressed.

It is generally assumed that the Jōmon people, both men and women, wore close fitting trousers tied at the waist with rope of braided cord and short upper garments with tubular sleeves. These upper garments were probably pullover shirts with V-necks and had either embroidered curvilinear designs or decorative painted designs. Such clothing does not seem to be well suited to the warm, humid climate of Japan, and may reflect a connection between Jōmon culture and the nomadic tribes of northern Asia.

Near the end of the Neolithic age, rice cultivation methods from the Asian continent were introduced to Japan, ushering in the cultural period known as Yayoi. Pottery of this period was turned on a wheel but was of much simpler design than the hand-formed Jōmon pottery.

The transformation from a hunting and gathering society to a more settled agrarian society must certainly have affected the way people dressed. In contrast to the close fitting hunting garments of the Jōmon period, the Yayoi people probably wore

loose fitting clothes better suited to the bending and stretching done in the course of work in the rice fields. In an early Chinese historical account, *Wei Chih*, there is a chapter known in Japanese as "Wajinden" concerning the people of Wa, that is Japan. In this report men are described as being clad in garments made of unsewn fabric wrapped around the body, while women were said to wear large cloths with holes cut in the center for their heads. This document is important as a first account of the early Japanese, but scholars have argued that much of it is biased and generally unreliable. It is not until the ensuing Tumulus period that a clearer picture of how the early Japanese dressed begins to emerge.

The formation of the Japanese state, known as Yamato, took place during the protohistorical period from A.D. 250 to 552. This age is referred to as the Tumulus period after the earth mounds built to cover the stone burial chambers of the rulers of the state. A number of these mounds are of enormous proportion, the best known being the Emperor Nintoku's tomb (died c. 399) in Sakai, Osaka Prefecture. Covering an area of 195 hectares, it rose to a height of twenty-one meters. Vases, jewels, mirrors, and iron and bronze weapons are among the objects found in the tombs. More important for the history of kimono are the sculptures known as *haniwa* (*figure 1*). These sometimes round (*wa*) and hollow clay (*hani*) objects were placed on and around the burial mounds.

The *haniwa*, which depicted weapons and other artifacts, animals, particularly horses, and, later, human beings, provide important clues as to how the people of this period dressed. The upper garments worn by both men and women, for example, opened in front and had close cut sleeves. Men are often shown wearing loose trousers, and women appear to have on a long pleated skirt, which came to be known as a *mo*. The general impression gained from the *haniwa* is of a style of dress very similar to the close fitting hunting outfits of northern Asia.

Missions sent to China during the Asuka period (552–646) brought back Buddhism, Confucianism and many other aspects of Sui and T'ang dynasty culture. This and the Nara period (646–794) were an era in which Japan sought the guidance of a country more advanced than herself. The Nara capital established in 710, for example, was modeled exactly on the Chinese capital of Ch'ang-an. Even the organization of the government was patterned after the symmetrically ordered Chinese system. The exhaustive codes forming the basis of this system were designed to regulate every aspect of every person's life, and people were classified into different ranks and required to wear clothes with colors and styles prescribed for each respective rank.

The man who inaugurated this revolutionary change was Prince Shōtoku, the imperial regent from 593 when he was thir-

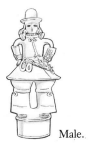
Male.

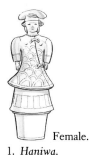
Female.

1. *Haniwa.*

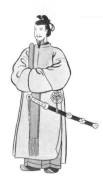

2. Man's court robe.

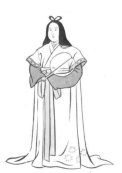

3. Woman's court robe.

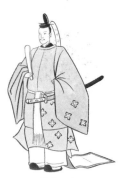

4. *Sokutai*.

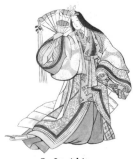

5. *Jūni-hitoe*.

ty to his death in 622. A believer in Buddhism, he actively propagated the religion and built many temples, among them the Hōryū-ji, where very important textile fragments from the Asuka and Nara periods have been preserved.

A kimono like Prince Shōtoku would have worn is shown in *figure 2*. It is a typically Chinese style dress with a loose upper garment slit on both sides, a stand-up collar and trousers. The trousers are held in place by a sash which, after being tied, hung down in front.

Court women's dress was also highly influenced by Chinese models. They wore a short upper garment and a long flowing skirt, as shown in *figure 3*.

The common people dressed in a style similar to that of the earlier Japanese. Men wore loose kimonolike upper garments with close fitting collars and tight sleeves. They tied the kimono with sashes and wore trousers to make working in the fields easier. Women also wore kimonolike upper garments which, unlike today, were overlapped from right to left. This upper garment was usually worn with a short undergarment and a skirt.

In 794 the imperial court moved north of Nara to Heian-kyō, "the capital of peace and tranquility." (Eleven centuries later the city was to be renamed Kyoto.) During the early Heian period (794–897), under such strong and active emperors as Kammu (781–806) and Saga (809–23), Japan continued to maintain relations with T'ang China. Then, as the power of the emperors began to wane, one family of courtiers, the Fujiwara, came to dominate the affairs of state. After 894 communication with China was suspended, and the period from 897 to 1185 is referred to as the late Heian, or Fujiwara, period. Japan then sought to develop her own artistic spirit. The shift in emphasis is clearly evident in the evolution of textile designs and in the styles of dress at all levels of society.

Life at the Heian court was without doubt one of the most refined and sophisticated in the world at that time, although an extraordinary concern for beauty, delicacy and sensitivity led eventually to a prescriptive aesthetics and empty formalism.

In this luxurious setting the court nobles wore long trailing robes called *sokutai* (*figure 4*). The sleeves (*ōsode*) were large and completely open at the end. Underneath this ceremonial outer robe was an undergarment with smaller sleeves, the *kosode*.

For the many ceremonial occasions, women of the Heian court wore unlined kimono one over the other, taking great care to match and contrast the colors of each layer, which were visible at the neck, sleeve ends and lower skirt (*figure 5*). This was called *jūni-hitoe*, meaning "twelve layers," but the actual number of kimono might have been less or more—even up to twenty layers weighing eight kilograms. Worn underneath were an under-kimono and a *hakama*. Then, as now, a woman's hair

was of great importance. Heian ladies favored long, lustrous black hair.

For less formal wear court nobles dressed in the *nōshi* (*figure 6*). Although the sleeves were long and full like those of the *sokutai*, various ornaments of rank were eliminated to facilitate freer movement.

Their hunting outfit was called *kariginu* (*figure 7*). With horseback riding and the drawing of a bow in mind, particular attention was given to the sleeves. These were narrow and were attached by sewing under the arm, but not at the top of the shoulder, and had strings at the cuffs with which they could be closed.

Shorter and less formal than the *kariginu* was the *suikan* (*figure 8*). The *suikan* was also worn by lower class people as a formal visiting garment, as a uniform by men who served the nobles, and towards the end of the Heian period as the ceremonial dress of warriors.

Such people as merchants wore beautifully designed unlined upper garments with broad sleeves, while common people were required to wear garments of a certain style. For men there was a *suikan* with a stand-up collar tied on the right and an early type of *hakama* (*figure 9*). Women wore kimono which were shortened by raising and tieing them in place (*figure 10*). At the bottom of the social scale, a maid servant would have a very simple outfit consisting of a loose fitting upper garment and a wraparound cloth skirt.

The artistically brilliant Heian period ended with the rise to power of military families. In 1185, after years of conflict, the Minamoto family defeated their rival, the Taira. While the imperial court remained in Kyoto, Kamakura in eastern Japan was chosen as the seat of the shogunate and gives its name to the period (1185–1333).

The Kyoto style kimono with its lavish use of material was impractical and, indeed, improper for men and women of the samurai class. The Kamakura style that evolved emphasized simplicity, even frugality.

For everyday wear the warriors put on the *hitatare* (*figure 11*). This garment seems to have been adapted from the working dress of farmers and was designed to allow free movement. *Hakama* were worn with a short upper garment, which like the earlier hunting outfits of the nobility had strings to close the cuffs when so desired.

The general's ceremonial dress, the *yoroi hitatare*, had less full sleeves and short trousers worn with leggings. Armor (*yoroi*) could be put on over it. *Figure 12* shows the *yoroi hitatare* and *figure 13* the *ōyoroi* donned by samurai when they were fully armed.

Rather than ostentatious multilayered kimono, women of the Kamakura period wore, over *hakama*, what had been an

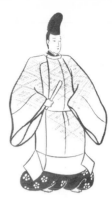

6. *Nōshi.*

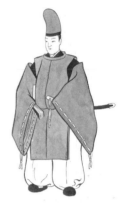

7. *Kariginu.*

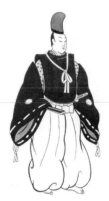

8. *Suikan.*

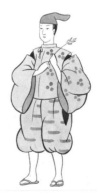

9. *Hakama.*

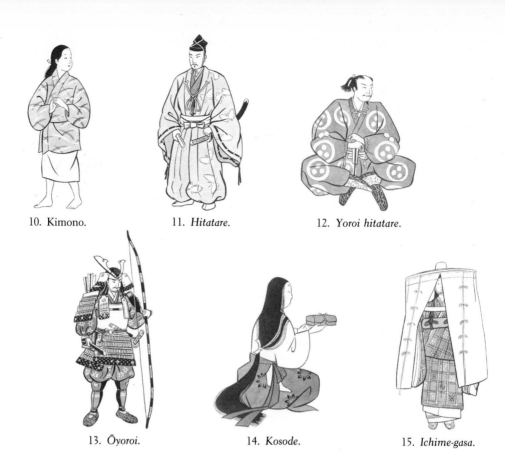

10. Kimono.

11. *Hitatare.*

12. *Yoroi hitatare.*

13. *Ōyoroi.*

14. *Kosode.*

15. *Ichime-gasa.*

undergarment, the *kosode* (*figure 14*). *Kosode* means "small sleeve," and whereas the sleeves had formerly been open at the end, the opening was made even smaller by being partially sewn up. In this development can be seen the beginning of the modern kimono.

Women of the samurai class would not, of course, immodestly display their faces in public. For traveling they would don a veil or an elaborate headdress known as *ichime-gasa* because of its resemblance to an umbrella (*kasa*) (*figure 15*). To shorten the kimono and keep it from dragging, they tied it with a sash around the chest. Along with the sash they wore bands on which were written prayers for a safe journey.

Over the years the Kamakura shogunate lost control of the provincial daimyo, and then in 1338 the Ashikaga shogunate established its headquarters in Kyoto. This Muromachi period (1338–1568) is notable for the opulence of its art and architecture and the refined aesthetics of the tea ceremony and the Nō drama. Both the shogun and the daimyo throughout the country devoted much time to the pursuit of the arts and many became patrons for men of letters, artists and craftsmen.

In dress the warrior ethic prevailed and determined, on the whole, what people wore. Fearing it would undermine their strength, the warriors eschewed the luxurious style of court life. This cautious attitude is reflected in their choice of the *suō* and *daimon* robes along with the *eboshi* cap (*figures 16* and *17*). Both

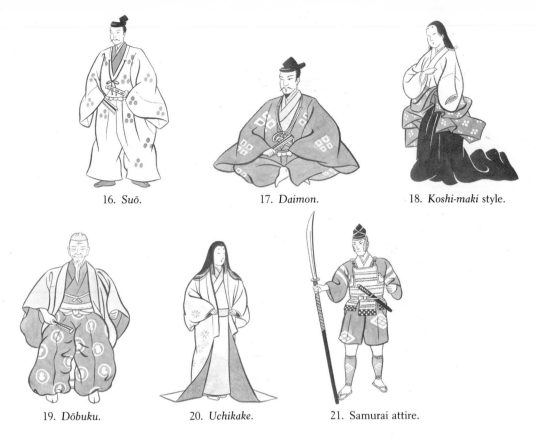

16. *Suō.* 17. *Daimon.* 18. *Koshi-maki* style.

19. *Dōbuku.* 20. *Uchikake.* 21. Samurai attire.

the *suō* and *daimon* were nearly identical to the *hitatare*. The main difference was in the kind of material used. Instead of the silk of the *hitatare*, these garments were made of less expensive linen and the cord at the neck was leather rather than braided cloth. The *daimon* also bore five family crests (*kamon*): two at the shoulders in front, two on the sleeves and one at the neck in back. This reflected the importance the daimyo attached to close-knit family organization. The *kamon* style later spread to merchants, artisans and many other people and has come down to the present day.

The *kosode* was adopted as the standard dress for women regardless of class, but for formal wear, there was the long outer robe known as *uchikake*. In summer this robe was slipped off the shoulders, tied at the waist, and allowed to drape on the floor. Worn with long trailing *hakama*, this is referred to as the *koshi-maki* style (*figure 18*).

Common people began wearing the *dōbuku*, a short coat similar to the *haori*. The *dōbuku* originated as the garb of street vendors, but toward the end of the Muromachi period, it came to be worn at home by upper class men (*figure 19*).

The last decades of the Muromachi period were marked by civil strife. Then, from the 1560s onward, Oda Nobunaga gained control of eastern Japan. After Nobunaga's death, his successor, Toyotomi Hideyoshi, carried on the work of reunifying the country. Building temples had been a major activity of

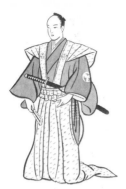

22. *Kamishimo.*

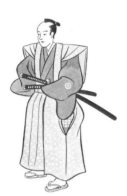

23. *Hakama.*

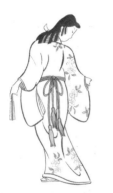

24. Braided Nagoya obi.

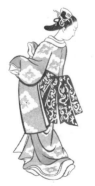

25. *Darari-musubi.*

previous periods; now it was building castles, and the site of one of Hideyoshi's castles gives the Momoyama period (1573–1603) its name.

With the rise of warriors and wealthy landowners to positions of authority, traditional forms and conventions changed; what was soon valued was anything new and novel. Women of all classes continued to wear the *kosode* in public, but the wives of powerful daimyo found richer and more elaborate kimono more in keeping with their status. On ceremonial occasions these women would carry a small purse called a *hakoseko* tucked between the front kimono panels just above the breasts. The ceremonial *kosode* and *uchikake* (ceremonial winter robe, *figure 20*) from this period is today the most formal bridal attire.

Warriors often had to travel long distances and so preferred dress and armor which were simpler and lighter. They wore trouserlike *hakama* and upper garments with drawstrings at the sleeve ends. The dress of lower ranking samurai was a kimono with tubular sleeves and short pants. They usually wore armor on the upper body alone (*figure 21*).

In 1603 Tokugawa Ieyasu, after having gained control of the whole country, founded the Tokugawa shogunate. His capital was Edo (now Tokyo), and the Edo period (1603–1868) was long, stable and peaceful. It was also almost totally free of influence from abroad, since the shogunate banned the Portuguese and Spanish missionaries and English traders who had come in the late fifteenth century and allowed only a few Dutch and Chinese merchants to carry on their business through the port of Nagasaki in Kyushu. The middle of the Edo period saw the rise of popular literature and art, such as *ukiyo-e*.

During this period the samurai altered the *kataginu*, a sleeveless upper garment favored by the working classes during the Muromachi and Momoyama periods, and incorporated it into their costume. Known now as the *kamishimo*, it was worn over the kimono and was combined with *hakama* to complete the ceremonial attire for high ranking samurai (*figure 22*). When the occasion was formal the *hakama* hems trailed on the floor, but for ordinary occasions, the hem was sewn up at the ankles (*figure 23*). This combination of kimono, *kamishimo* and *hakama* was later adopted by scholars and men of wealth.

It was in the clothes of women that the most significant changes occurred. Widespread acceptance of the *kosode* was accelerated in the Edo period through the influence exerted on fashions by courtesans, entertainers and Kabuki actors, who took to wearing increasingly elaborate and colorful *kosode* kimono. This style was derived by combining the tubular sleeve kimono worn by farmers and the *kosode* of upper class women. In order not to detract from the beauty of the kimono itself, the obi of the early Edo period was a simple one made of braided cords (*figure 24*).

Attention gradually shifted in the middle of the Edo period from the kimono to the obi. Although designers were still producing creative and beautiful *kosode* designs, they were also looking to the obi for new possibilities in kimono fashion, for there arose a class of people, townsmen for the most part, who were not fettered by the strict samurai codes of dress and who were attracted to whatever was new and experimental. While samurai women continued to dress in simple and restrained kimono, women outside this class, influenced by the fashion-leading actors and courtesans, wore *furisode* kimono with large obi tied loosely in the *darari-musubi* style (*figure 25*). The *furisode* is characterized by long very full sleeves, for it was said at one time that a woman could win the man she loved by waving (*furi*) her sleeve (*sode*) to attract his spirit, even from afar. The *furisode* is, needless to say, a kimono worn only by unmarried women.

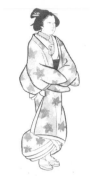

26. *Uchikake* and *hakoseko*.

Later there was some blurring of the distinctions between the social classes. All women began wearing a similar style of kimono. Wealth, rather than class, was the standard of distinction, and the *uchikake* with its elaborate patterns was no longer strictly for women of nobility. *Figure 26* shows a woman in the *uchikake* robe, worn over a *kosode*, with a small *hakoseko* purse inserted between the front panels at the collar.

By 1868 the Tokugawa policy of self-imposed isolation was no longer feasible. The Emperor Meiji moved with his court from Kyoto to Tokyo, a constitutional monarchy was formed, and the country set out to master the science and technology that made the western nations economically strong. During the Meiji period (1868–1912) the country was flooded with many styles of western dress, especially long dresses and trousers (*figure 27*). Styles were sometimes mixed, and boys of school age might wear either western style uniforms or clothes showing both western and Japanese influence (*figure 28*).

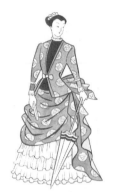

27. Long dress.

Women's kimono ceased to be worn in the free flowing style of earlier periods. They were tucked in at the waist in accordance with a person's height. The hems were raised and the sleeves made shorter. In a style that has not survived, women could be seen wearing kimono with a *hakama* and high shoes (*figure 29*).

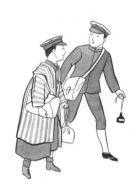

28. School uniforms.

The obi, too, was made shorter and obi bows much simpler, one of the most popular being the *taiko musubi* or "drum bow" (*figure 30*). This bow takes its name from an arched drum-shaped bridge (Taiko-bashi) at the Tenjin Shrine in Kameido, Tokyo. The bow was created in the late Edo period by the Fukagawa geisha especially for the ceremony commemorating the opening of the bridge. There are many variations of the *taiko musubi*, it is still very popular, and can be considered representative of obi bows.

Men of the Meiji period most often wore a sack suit for

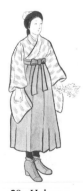

29. *Hakama*.

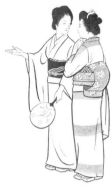

30. *Taiko musubi.*

everyday wear, reserving the kimono, *haori* and *hakama* ensemble for ceremonial and formal occasions.

The history of kimono does not end with the Meiji period, but it is only natural to devote the greatest attention to the earlier periods, for it can be said that kimono styles, and to a lesser extent, obi styles, became standardized in the late Edo and Meiji periods. In the years since then, as the Japanese increasingly took to western clothes, fashion designers looked more and more to the West for their inspiration.

The wearing of kimono reached a nadir during the first two decades of the postwar period. Nowadays, although there are relatively few women—and almost no men—who prefer the kimono for everyday wear, many are beginning to rediscover the subtle beauty and attractiveness of Japan's national costume.

The Kimono

Weaving and Dyeing

All kimono are the same shape and are of a standard size that can be worn by anyone, man or woman, regardless of height or weight. This gives the kimono a versatility not found in typical western dress.

Unlike western dressmaking with its varied and sometimes individual patterns, the kimono is made from a single basic pattern. When kimono cloth is being woven or cut or sewn, it is always perfectly straight and flat, and the finished garment can be taken apart and then resewn into its original form, as is done when a kimono is cleaned. This simplicity of form makes it possible for the kimono, and the obi, *haori* and *hakama* as well, to be folded in a flat rectangular shape for storage. The basic pattern of the kimono, its parts and the standard size are shown in *figures 1–3*.

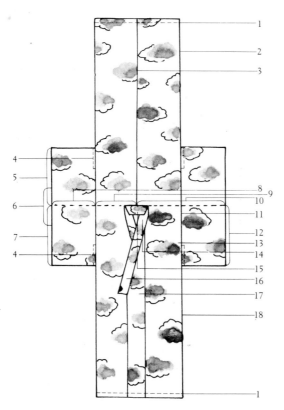

1. BASIC KIMONO PATTERN

1. *Suso*—Hem.
2. *Ushiro migoro*—Back of body section.
3. *Senui*—Back mid seam.
4. *Furi*—Sleeve below armhole.
5. *Ushiro sode*—Back of sleeve.
6. *Sodeguchi*—Sleeve opening.
7. *Mae sode*—Front of sleeve.
8. *Sode haba*—Sleeve width.
9. *Kata haba*—Shoulder width.
10. *Yuki*—Sleeve plus shoulder width.
11. *Sodetsuke*—Armhole seam.
12. *Sodetake*—Sleeve depth.
13. *Miyatsuguchi*—Opening under armhole.
14. *Eri*—Collar.
15. *Tomoeri*—Over-collar.
16. *Erisaki*—Collar end.
17. *Erishita*—Length under collar.
18. *Mae migoro*—Front of body section.

2-3. PARTS OF THE KIMONO

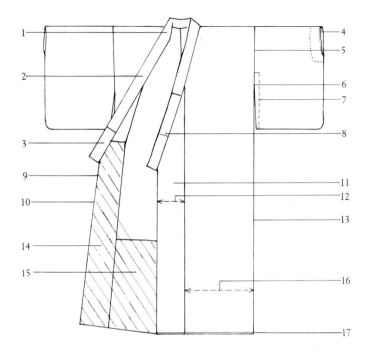

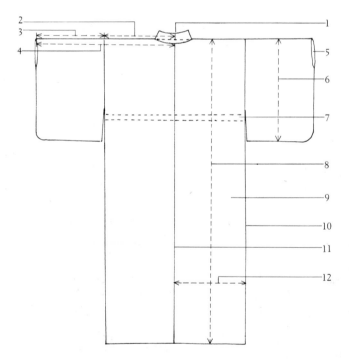

Front

1. *Tomoeri*—Over-collar.
2. *Ura eri*—Back of collar.
3. *Erisaki*—Collar end.
4. *Sodeguchi fuki*—Lining at sleeve opening.
5. *Sodetsuke*—Armhole seam.
6. *Miyatsuguchi*—Opening under armhole.
7. *Furi*—Sleeve below armhole.
8. *Eri haba*—Collar width.
9. *Shitamae migoro*—Inner front panel.
10. *Erishita*—Length under collar.
11. *Okumi*—Front panel below collar end.
12. *Okumi haba*—Width of front panel below collar end.
13. *Uwamae migoro*—Outer front panel.
14. *Susomawashi*—Lining of front panel below collar end.
15. *Hakkake*—Lining of back of kimono.
16. *Mae haba*—Front width.
17. *Susosen*—Hemline.

Back

1. *Eri*—Collar.
2. *Kata haba*—Shoulder width.
3. *Sode haba*—Sleeve width.
4. *Yuki*—Sleeve plus shoulder width.
5. *Sodeguchi*—Sleeve opening.
6. *Sodetake*—Depth of sleeve.
7. *Kurikoshi*—Fold-over sewn to adjust length.
8. *Mitake*—Length from shoulder to hem.
9. *Ushiro migoro*—Back of body section.
10. *Wakinui*—Side seam.
11. *Senui*—Back mid seam.
12. *Ushiro haba*—Back width.

STANDARD KIMONO SIZE

Length: 158 cm.
Sleeve plus shoulder width: 63 cm.
Sleeve width: 32 cm.
Shoulder width: 31 cm.
Sleeve depth: 49 cm.

A multitude of variations in women's kimono are achieved through the use of many kinds of textiles and patterns. Textiles may be natural—silk, cotton, linen, wool—or, nowadays, synthetic fabrics. Patterns, handmade or machine-made, are produced by many methods: weaving, hand-painted or stencil dyeing, tie-dyeing, embroidery or a combination of techniques. Weaving kimono textiles is done by hand even today, but as with other arts and crafts, this method is very expensive, so the majority of kimono fabrics are now made by machine.

Kimono are classified according to whether the dyeing process is done before or after the weaving process (*saki-zome* or *ato-zome*).

Pre-dyed (*saki-zome*) kimono are referred to as woven kimono. The designs are symmetrical or geometric, such as stripes, checks or the splash pattern known as *kasuri*. These are customarily broken down into the following types:

> Silk: reeled silk (*meisen* or *habutae*), heavy crepe (*omeshi*), spun silk (*tsumugi*), silk gauze (*sha*) and leno weave gauze (*ro*).
> Cotton: splash pattern (*kasuri*), stripe pattern (*shima*) and check (or lattice) pattern (*kōshi*).
> Linen (*jōfu*).

Woven kimono are also made of wool or synthetic fabrics.

Kimono dyed after weaving the cloth (*ato-zome*) are referred to as dyed kimono. These free-style designs and motifs first became popular during the long Edo period, as innovative developments occurred in dyeing and decorating techniques. There are many kinds, classified by the design process:

> Designs dyed on white fabric (*gara-zome*):
> Hand-painted designs (*tegaki-zome*): Yūzen, batik (*rōke-tsu*) and others.
> Stencil designs (*kata-zome*): hand-drawn Yūzen designs (*kata* Yūzen), small stencil designs (*kata komon*), small monochrome patterns (Edo *komon*), polychrome dyeing over stencil resist (*bingata*), and medium-size stencils (*chū-gata*, used only for *yukata*).
> Tie-dye (*kasuri-zome*).
> Patternless monochrome dyeing (*muji-zome*).

Many textile techniques have reached a high level of sophistication in Japan. Two that are especially important traditionally, and are still in use today, are *tsumugi* (spun silk) and Yūzen, a starch-resist dyeing technique unique to Japan.

TSUMUGI

Tsumugi originated with farmers who wished to make use of cocoons left over after they had shipped their best silk to market. They would diligently collect the floss from the co-

coons, spin (*tsumugu*) it by hand into thread and weave kimono for themselves and their families. Later the production of *tsumugi* became an important local industry, and the fabric was made in almost every prefecture in Japan. Particularly well known are *tsumugi* from Yūki, Ōshima, Kumejima and Tō-kamachi, but there are many others as well.

The fact that the same person might spin the thread, weave the cloth, and sew and wear a kimono lends *tsumugi* a prized individuality, as does the way a kimono slowly conforms to its wearer. Before weaving, starch is applied to the thread to make it smoother and keep it from unraveling. When the kimono is first worn, the starch makes it rather stiff, but as time goes by, the starch comes out of the garment and it becomes quite comfortable for the wearer.

The first step in making *tsumugi* is to degum the floss by immersing it in hot water containing baking soda and sulfurous acid. Five or six cocoons are formed into a small bag shape (*fukuro mawata*) to make them easier to handle. The floss is rinsed in water and the process is repeated. Drying is done in a breezy place out of the sunlight (*figure 4*). To make the filament

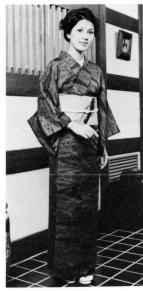

Ōshima *tsumugi* kimono.

4. Drying *fukuro mawata*.

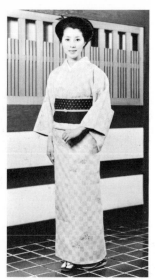

Yūki *tsumugi* kimono.

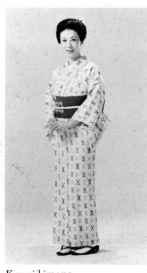

Kasuri kimono.

easier to pull from the floss, the floss is soaked in a mixture of powdered sesame seeds and water.

Spinning is done by attaching the *fukuro mawata* to a device made of bamboo and corn or cane stalks and known as a *tsukushi (figure 5)*. Several filaments are drawn from the floss at one time and twisted to form a single thread *(figure 6)*. The spinner wets the thread with saliva. Middle-aged women are considered best for this work, since young women have too high a hormone content in their saliva and old women's saliva is too low in hormone content. Interestingly enough, it is said that the best thread is made by women who are beautiful.

The thread produced by this method is strong, elastic and glossy. Depending on the pattern, spinning thread for one kimono takes from 20 to 45 days. Making a *kasuri* kimono of the *jūji no kagasuri* type requires 102 days.

Stripes, checks and the splash pattern *kasuri* are the principal designs for *tsumugi* kimono, as they are for woven kimono in general, but hand-painted ones may also be seen. It is *kasuri* weaving that produces the boldest and most creative designs for woven kimono.

Kasuri is a tie-dye technique that originated in India, spread to the islands of the South Pacific and was brought to Okinawa in the fifteenth or sixteenth century. After reaching Japan proper, it evolved into freer and more complex designs.

The basic *kasuri* patterns are cross and parallel cross designs. More complex are the pictorial *kasuri*, where pines, bamboo, plum blossoms, cranes, tortoises and so on are woven into the design. Notable examples of these are made in Fukuoka Prefecture, *kurume-gasuri*; Ehime Prefecture, Iyo-*gasuri*; and Okinawa Prefecture, Ryukyu-*gasuri*.

Kasuri weaving begins with dyeing the thread. Bundles of thread are wrapped with white cotton thread, so that certain sections of the bundles take the dye and others do not. The dyes are either natural vegetable dyes such as indigo with, perhaps, mud dyes (used as a mordant) or chemical dyes.

A little dye invariably penetrates the reserved area causing irregular bleeding. This fading and merging of the dyed and undyed areas is one of *kasuri*'s enduring and unique qualities. Once the thread is dyed and set, the bundles are untied, revealing vivid possibilities to be worked out during weaving.

Weaving *tsumugi* is done on a seated loom, a standing loom or a power loom. The Japanese seated loom known as *izaribata* has a history of more than a thousand years *(figure 7)*. Work on this loom proceeds at a rate of 61–76 cm. per day. After the material is woven, it is steamed.

Kimono made of *tsumugi* are warm and comfortable and have a simple rustic and homemade feeling. One of the most popular of kimono fabrics, *tsumugi* can be worn at home or for informal gatherings and parties.

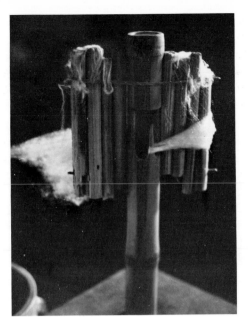

5. *Tsukushi.*

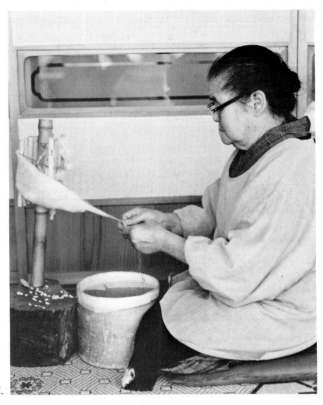

6. Hand spinning *tsumugi.*

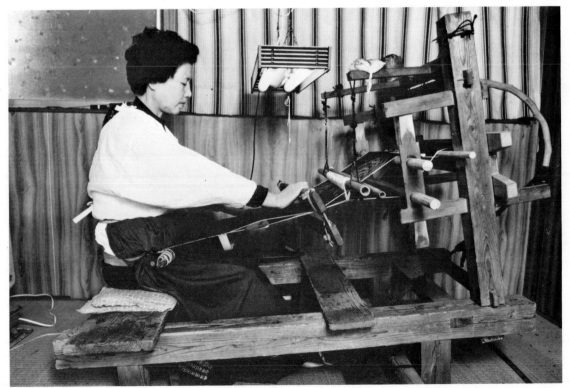

7. *Izaribata* loom.

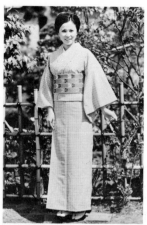

Kihachijō kimono.

KIHACHIJŌ

This *tsumugi* is a yellow (*ki*) cloth first made on Hachijō Island near Tokyo. The bright yellow color is produced from a dye extracted from the *kariyasu* grass found in abundance on the island. The characteristic design is stripes or checks, handmade in either plain weave or twill. Other Hachijō kimono are dyed in brown or in black. *Tobi* (brown) Hachijō dye comes from the madami plant. *Kuro* (black) Hachijō dye comes from the bark of the chinquapin. There is also a Hachijō textile produced in Akita Prefecture.

YŪZEN

Yūzen is a starch-resist dyeing technique and was invented by Miyazaki Yūzen, a famous Kyoto fan-painter during the Genroku era (1688–1704) of the Edo period. Up until then the powerfully expressive geometric designs created by direct dyeing and tie-dyeing methods lacked freedom and subtlety in composition and color. Miyazaki Yūzen's technique, using glutinous rice as the resist, started a revolution in the dyeing of free-style designs and led to the delicately subtle depiction of small flowers, birds, maple leaves, spring and autumn grasses and so on. Yūzen-dyed kimono with their hand-painted pictorial designs soon came to be prized by women of all classes in Edo period Japan.

According to some accounts Miyazaki Yūzen moved to Kaga in Ishikawa Prefecture, where he began producing Yūzen designs in colors slightly more subdued and provincial than his Kyoto creations (Kyō Yūzen). These Kaga designs (Kaga Yūzen) were noted especially for harmoniously blending colors and designs and for the realistic touches in the designs themselves.

In producing Yūzen the pictorial or graphic design is first drawn with juice squeezed from spiderworts onto a plain white cloth pattern sewn into the shape of a kimono (*figure 8*). The pattern cloth is then taken apart and attached to the corresponding parts of the kimono itself. The outline of the pictorial design is starched with rice paste (*figure 9*) so the dyes do not bleed, and soybean juice is brushed onto the kimono cloth to insure a good dye. Then the colors are brushed into the shaded and floral design areas (*figure 10*). To set the dyes, the cloth is steamed at 100°C. in a cypress steam box for forty minutes. If the base color is other than white, starch is applied again, this time onto the design areas (*figure 11*), and the material is dyed with the base color and steamed again (*figure 12*). After dyeing, the starch is rinsed out. Traditionally this was done in flowing river waters, but nowadays the rinsing process is completed in specially designed running water troughs (*figure 13*).

As chemical dyes became readily available during the Meiji period, pattern dyeing came into favor. Pattern dyeing is a process in which designs are cut in patterns for each color. Ten to

fifty paper patterns are usually employed for most kimono designs, but on occasion up to three hundred patterns have been used. For Yūzen pattern dyeing white cloth is first placed on a dye board. The paper patterns are then placed over the cloth. Starch containing dye is spread with a wooden spatula and passes through the holes cut in the pattern and onto the fabric. The process is repeated to dye the base color. After rinsing and steaming, the design may be embellished with embroidery or gold leaf.

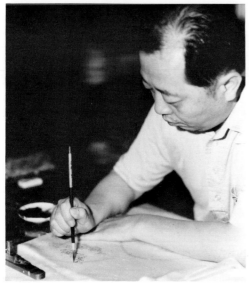

8. Drawing Yūzen design.

9. Applying rice paste resist.

10. Brushing in design color.

11. Applying resist to design area.

12. Applying base color.

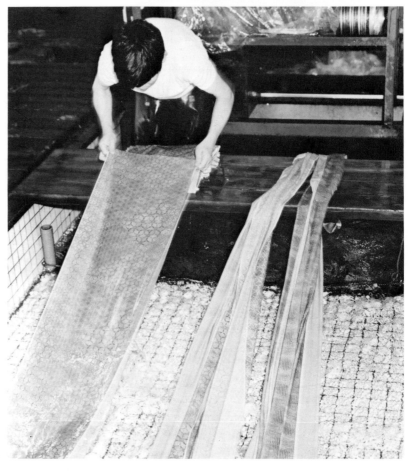

13. Rinsing dyed fabric.

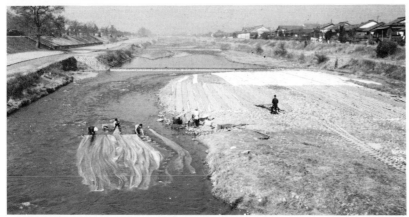
Traditionally, Yūzen textiles were rinsed in swift-flowing river waters after being dyed.

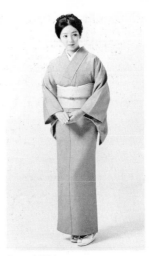
Iro muji kimono.

IRO MUJI

The material for this kimono is figured satin (*mon rinzu*), crepe (*chirimen*) or *tsumugi* dyed in a single color other than black. This makes a versatile kimono and can be worn by either married or single women. It may be worn for formal occasions when a single crest is attached in back. *Iro muji* means that it is colored and has no dyed pattern, but figured satin, of course, has a raised pattern.

TSUKESAGE

Tsukesage refers to the way in which the patterns are dyed. From the hemline at front and back the patterns go upward and meet at the top of the shoulders, those on the sleeves at the top of the sleeves. Depending on the elaborateness of the design, this kimono may be worn at either formal or informal gatherings. For formal wear, a crest should be embroidered or dyed at the back seam.

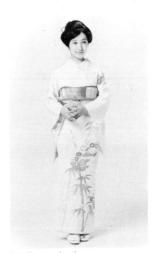
Tsukesage kimono.

KOMON

Kata-zome are patterns printed from woodblocks or dyed using stencils, which long ago were also made from wood. When thick paper took the place of wood, cutting stencils became a much simpler operation, making possible large scale, economical production of stencil-dyed kimono. Another advantage was that paper stencils allowed craftsmen to create small delicate designs known as *komon*. Since kimono completely covered with the same *komon* design were especially popular in Edo, this type of dyeing came to be known as Edo *komon*. Edo *komon* are small exquisite designs of a single color; from a distance the material may appear to have no pattern at all.

Another type is Yūzen *komon*, which has colorful pictorial designs and is very popular among young women.

The material for *komon* kimono is figured satin (*mon rinzu*), crepe (*chirimen*) or *tsumugi*, and they are worn with the double-fold (*fukuro*) obi, the Nagoya obi or the double-fold Nagoya obi.

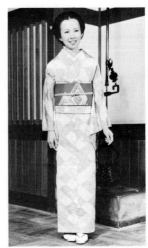
Komon kimono.

OMESHI

Long ago *omeshi* was an honorific term for kimono worn by those at the imperial court. Later it was used as the name of a kimono fabric, a certain kind of silk crepe. After the sericin is removed from the silk by boiling, the thread is dyed and waxed. In weaving the weft threads are crossed and are woven two together.

Omeshi kimono can be worn for various occasions. Appropriate for visiting are kimono decorated with picture designs that run continuously over the seams (*eba-zuke*). *Omeshi* with stripe or *kasuri* patterns may be put on for everyday wear.

WOOL

The convenience of wool has led to a growing popularity for everyday wear both at home and in town. Since unlined wool kimono can be dry-cleaned without having to be taken apart, they are very practical. Warm and comfortable, wool remains relatively wrinkle free and can be sewn either by hand or by machine. Heavy wool material with an inner lining can be worn in winter, while lighter wools make a nice summer kimono. Wool kimono are usually worn with the Nagoya obi or the half-width (*han haba*) obi.

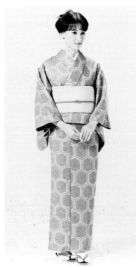

Omeshi kimono.

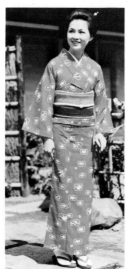

Wool kimono.

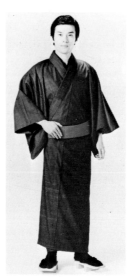

Wool kimono.

Wool kimono and *haori*.

YUKATA

The *yukata* is an unlined cotton kimono. Traditionally it was put on after coming out of a hot steaming bath. It is now most conspicuous during the summer months, particularly at the celebration of festivals.

Yukata designs give an impression of coolness and informality. Navy blue designs on a white base or white designs on a navy blue base are often seen, but among young people *yukata* in colorful patterns are sometimes preferred.

Unlike other kimono, the full-length under-kimono is not worn with the *yukata*. The favored underwear is made of cotton crepe. The obi may be the Nagoya obi or the half-width obi. Wooden sandals (*geta*) are worn on the feet, rather than *tabi* or *zōri*.

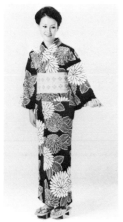 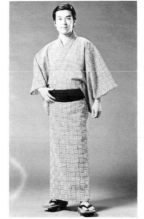

Yukata summer kimono. *Yukata* summer kimono.

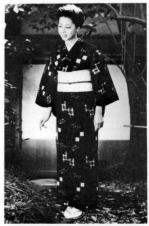

Shuri (Okinawa) *jōfu* kimono.

JŌFU

Jōfu are kimono handwoven of fine linen, which is what *jōfu* means. Airy and cool to the touch, this kimono is a favorite among summer kimono. It may be combined with a silk obi of either leno weave (*ro*) or gauze weave (*sha*). Cotton or linen should be used for the inner collars.

Formal Kimono

The kimono described up to this point all take their names from the way in which the textiles are woven or dyed, and a particular kimono may incorporate more than one technique, such as spun silk (*tsumugi*) in a yellow check pattern (Kihachijō) or crepe silk (*omeshi*) in a splash pattern (*kasuri*).

Another way of classifying kimono derives from whether they are worn by married or single women and the kind of occasion on which they are worn.

KURO TOMESODE

The most formal kimono for a married woman is the five crested *kuro* (black) *tomesode*. In contrast to the long "waving" sleeves of the *furisode*, *tomesode* sleeves are shorter and the sleeve opening smaller, since it would not be appropriate for a married woman to wave her sleeve to attract a lover as an unmarried woman might do. The five family crests in white and the designs on the skirt create an impressive black and white contrast. The elegance of this kimono is further heightened by the white under-kimono, made of *habutae* silk or silk crepe (*rinzu*), whose collar sharply defines the lines of the kimono.

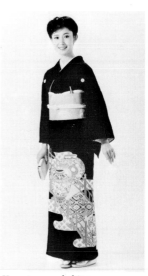

Kuro tomesode kimono.

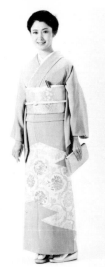

Iro tomesode kimono.

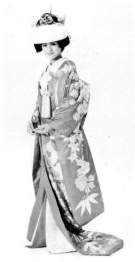

Uchikake bridal robe.

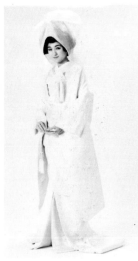

Shiromuku bridal kimono.

The double-fold (*fukuro*) obi woven with gold or silver thread is worn with this kimono along with the bustle sash (obi-*age*) made of dappled white (*kanoko*) tie-dye. The obi cord (obi-*jime*) may be either a white, round, blindstitched silk cord or a gold or silver braided silk cord. The sandals (*zōri*) should be either gold or silver.

IRO TOMESODE

This kimono when dyed or sewn with five crests may be worn by married women on formal occasions. Although the colors and designs give it a lighter and more festive air, the *iro* (colored) *tomesode* ranks next to the black *tomesode* among formal kimono wear. In the past this kimono was worn by court ladies. Today it is worn at formal parties and gatherings.

UCHIKAKE

Until the Edo period the *uchikake*, a full-length outer robe, was a garment worn by ladies of warrior or noble families on ceremonial occasions. Since that time it has come to be part of the traditional Japanese bridal costume. The *uchikake* is made of wadded silk and has long flowing sleeves. It is worn over the *kakeshita* kimono and is tied with the *kakeshita* obi. The cotton filling weighs down the hemline and serves to give this kimono an elegant and regal air.

SHIROMUKU

The name for this traditional bridal kimono combines *shiro*, "white," and *muku*, "pure," signifying the purity of the bride's intention to fit into her husband's family. It was believed that the bride dressed in white was open in heart to "be dyed," that is, to accept and learn the customs and ways of her husband's household.

The *shiromuku* is entirely white, except for the crimson inner lining of the *uchikake* and the pine or chrysanthemum designs, symbolizing good fortune, often embroidered on the front of the *uchikake* and on the inner collar.

FURISODE

The most important kimono in a single woman's wardrobe is the *furisode* with its long flowing sleeves, richly decorative designs and beautifully blended colors. In the past only the black *furisode* was worn on formal occasions, but today colored *furisode* are highly visible at formal and ceremonial occasions. The patterns which run continuously over the seams (*eba-zuke*) are produced with traditional and very elaborate techniques: hand painting, gold-leafing and fine embroidery.

Sleeve length varies from full length (*ōburisode*, 105 cm.) through medium length (*chūburisode*, 90 cm.) to short (*ko-furisode*, 75 cm.).

Most becoming with this kimono are the fully patterned double-fold obi tied in the plump sparrow (*fukura suzume*) bow or the box (*bunko*) bow. The *date eri*, a detachable collar, accentuates the kimono neckline, and colorful bustle sashes and obi cords are selected to heighten this kimono's young and lively appearance.

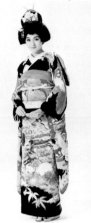 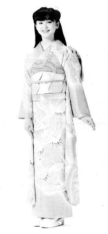

Ōburisode kimono. Chūburisode kimono.

HŌMONGI

Hōmon means "visit" and *gi* means "wear." This is a formal kimono worn by single or married women when visiting or calling on someone. It is a simplified version of the *furisode* and *tomesode*.

Hōmongi kimono are most often lined with a material different from the kimono itself and are decorated with full patterns running continuously over the seams. Sleeve length varies between 55 and 70 cm. Unmarried women tend to wear their sleeves somewhat longer.

This kimono is usually worn with the double-fold (*fukuro*) obi with matching bustle sash and obi cord.

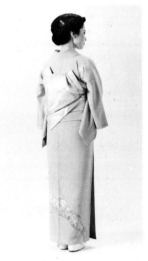

Hōmongi kimono.

MOFUKU

The *mofuku* (mourning wear) is a five crested black silk kimono without any woven pattern or design. The obi, bustle sash, obi cord and sandals should be black. The only white apparel are the split-toed socks (*tabi*) and full-length under-kimono. Slightly less formal than this is the crested, dyed *mofuku* kimono without patterns worn with a black obi.

As the foregoing suggests, selecting a kimono for a particular occasion requires careful consideration of a number of factors, such as the nature of the occasion and one's relation to other persons attending the function. The following chart summarizes which kimono are the appropriate ones for different occasions.

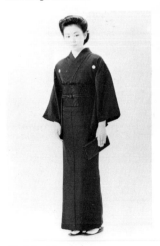

Mofuku kimono.

Formality	Occasion	Kimono
Ceremonial	When social status is emphasized: official function, wedding ceremony, funeral	Black *tomesode*, *uchikake*, mourning
Formal	Wedding, formal reception, formal party	Colored *tomesode*, *furisode*, crested *iro muji*, crested Edo *komon*, *tsukesage hōmongi*
Visiting	Visiting, school entrance or graduation ceremony, party, large meeting or gathering	Edo *komon* (without crests), *tsukesage komon*, *iro muji* (without crests), tie-dye *komon*, *omeshi*, *tsumugi*
In town	Shopping, meeting friends, traveling	*Komon*, *omeshi*, *tsumugi*
Everyday	At home	*Tsumugi*, wool, *yukata*

The Haori and Accessories

Outer Garments

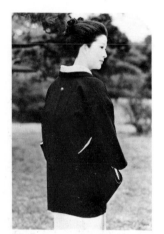

Black *haori* with crest.

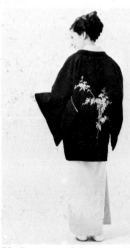

Black patterned *haori*.

Kimono are often worn without an outer garment, but when one is desired, there are several types to choose from.

HAORI

The *haori*, a lightweight coat, probably evolved from the *dōchū-gi*, formerly a cape worn for traveling. The word *haori* is a form of the verb *haoru*, which means "to put on."

The *haori* is still regarded as an essential feature of the ceremonial kimono attire for men (along with the *hakama*) but not for women. In fact, the wearing of *haori* by women did not become fashionable until the Edo period when the geisha from Tatsumi who lived in the pleasure quarter of Fukagawa in Edo took to wearing the *haori* in imitation of men's kimono attire.

Women put on the *haori* mainly to prevent the kimono from becoming soiled or wet. It is usually taken off and folded up before entering the place one is about to visit.

Haori are made in different lengths. The long *haori* is very dressy, the medium length *haori* is for ordinary wear, and the short *haori* is the type to be worn at home. For formal and semiformal wear, there are black and colored *haori*.

The black *haori* made of silk or crepe and bearing a single family crest at the back mid seam is called the *kuro montsuki haori*. It is worn for school events such as entrance and gradua- tion ceremonies or for mourning. Contrary to the general rule, this *haori* need not be taken off when inside a room. The *haori* cords should be black for mourning and white for school events.

The designs (*eba*) on colored *haori* extend over the seams of the material. The base color is any color other than black. This *haori* is often donned to go visiting on New Year's Day and for other felicitous occasions and is usually worn over a patternless kimono, or the Edo *komon* or *tsukesage* kimono. It is important to harmonize the basic colors of the kimono and the *haori*.

MICHIYUKI

The *michiyuki* (literally, "while on the road") is a three-quarter length coat, typically with the collar at the neckline in the form of a square. Materials for this coat are crepe, satin or

spun silk, and it is woven either without patterns or with small-pattern, stripe or check designs. A dyed patternless coat goes well with the *tomesode, hōmongi* and *tsukesage* kimono. Coats with small patterns, stripes or checks go best with spun silk and small pattern kimono.

DŌCHŪ-GI

This is an overcoat designed to protect the kimono from dust and to keep warm when outside during the winter. The collar looks like the kimono collar, and the length can be adjusted to make either a half-length coat or a three-quarter length coat. Spun silk, wool and small patterns make nice coats which can be worn with travel or visiting kimono, such as *tsumugi* or *komon*.

KIMONO RAINCOAT

The kimono raincoat covers the kimono completely. Popular materials are Nishijin brocade, satin and spun silk. The kimono raincoat, dyed without shadings or with shadings or stripes, is of course waterproof. There are also transparent nylon coats. These can be folded into a small packet and carried conveniently in a handbag.

SHAWL

The materials for shawls and stoles are such things as fur, velvet, cashmere, spun silk and crepe. The designs vary and include small patterns as well as dyed designs with shading and stripes. A fur stole is for formal wear. For early spring and autumn there are lace shawls.

Undergarments

The kimono wraps and covers the whole body. To wear it properly, some thought must be given to just how clothing is best worn.

Women putting on certain styles of Western clothes strive to present sharp, distinct and well-defined physical features: a firm bust line, a slim waistline and a shapely hipline. If the kimono were put on over undergarments designed to give this effect, the collar panels would quickly separate and open at the front, the obi would wrinkle, and the bottom hemline would spread open, spoiling the appearance of the entire ensemble.

The effect of kimono undergarments should be to suppress and soften the contours of the body. It is important to choose underclothes that create a smooth and rounded physical outline.

BRASSIERE

The brassiere is designed to press down, rather than uplift

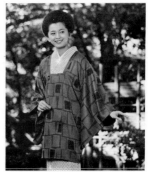

Michiyuki coat.

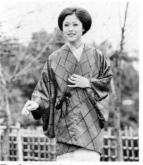

Dōchū-gi coat.

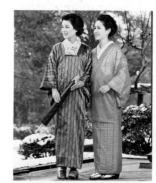

Kimono raincoats. *Left*: foldable raincoat of nylon. *Right*: transparent plastic raincoat.

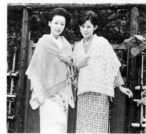

Kimono shawls.

the bust, so that the bust line is not prominent. A brassiere that fastens in front is most convenient when wearing a kimono.

UNDERPANTS

Putting on and taking off underpants easily wrinkles the kimono, so those that open at the bottom, or zip at the sides, or bikini-type panties are recommended.

CORSET

The majority of Japanese women do not find it necessary to wear a corset, but for those who wish to firm the waistline, a corset that opens at the bottom with magic tape is recommended. If this is worn, it will not have to be pulled up and down once the kimono has been put on.

HADAJUBAN

The *hadajuban* is an undershirt (*juban*) worn next to the skin (*hada*). In summer a *hadajuban* of bleached cotton or gauze is easy to wear because it is highly absorbent. One made of an airy crepe material is also comfortable for summer wear.

SUSOYOKE

The *susoyoke* is a half-slip and makes walking in the kimono easier. There are two types, the wraparound type and the skirt type. The wraparound *susoyoke*, which shows a more attractive hipline, is a single piece of cloth with strings to tie at the waist. Both types are available in many different materials and colors, such as crepe and satin, and synthetic fabrics like nylon, polyester and rayon.

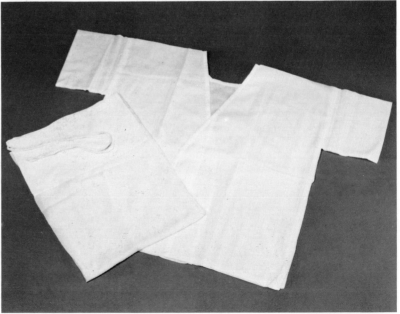

Hadajuban and *susoyoke*.

NAGAJUBAN

The *nagajuban*, or full-length under-kimono, is worn over the *hadajuban* and *susoyoke*. The under-kimono is lined or unlined, depending on the season. It is made of crepe, synthetic fabrics, leno weave gauze or linen, the latter two being for summer wear. For formal wear, the *nagajuban* is white or light colored. There are also under-kimono with sleeves having either small patterns or dyed in dark colors.

HAN ERI

A half-collar sewn to the collar of the under-kimono, the *han eri* is usually white, although colored half-collars are also worn for dressy occasions. Since the half-collar is visible under the kimono collar, it provides a well-defined and clean kimono neckline. *Han eri* are made of crepe, satin, linen, leno weave gauze or Shioze silk.

DATE-JIME

The *date-jime* is a waistband to keep the *nagajuban* in place. It is lined with silk, crepe, nylon or polyester. A waistband made of elegant Hakata weave has easy-to-tie ends. There are also elastic waistbands.

Nagajuban.

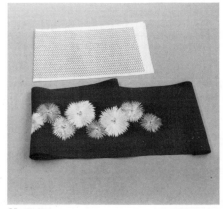

Han eri.

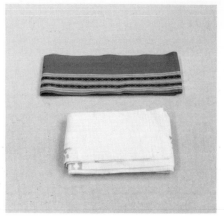

Date-jime.

Footwear

TABI

Tabi are pure white, lined, split-toed socks worn outdoors with *zōri* sandals and are also worn indoors. Silk, velveteen, calico, wool and synthetic fabrics are used to make *tabi*, and they are lined with cotton. *Tabi* should fit very snugly. A person who wears a 24-cm. shoe should have *tabi* in a 23.8-cm. size.

ZŌRI

Worn outdoors with *tabi*, *zōri* sandals nicely enhance the beauty of the kimono. There are cloth, leather and vinyl *zōri* and summer *zōri* made of plant fibers. Cloth *zōri* of gold silk brocade, Saga brocade or figured brocade are for wear on ceremonial occasions, as are enamel processed leather *zōri*. The height of the heels should be 4–5 cm. when wearing a ceremonial kimono, 3.5–4 cm. when wearing *hōmongi* or small pattern kimono and 2.5–3 cm. for casual wear. The color of the sandals should match the base color of the kimono, or they can be coordinated with the color of the obi cord or bustle sash.

GETA

Geta are raised wooden sandals with straps for wear with casual kimono or the *yukata*. The woods used are paulownia, cedar, cypress, chestnut and oak. Some *geta* are naturally finished paulownia; others are painted white. *Tabi* are not usually worn. The straps are velveteen or leather, but *geta* for rainwear have a covering over the toes and straps made of vinyl.

Tabi.

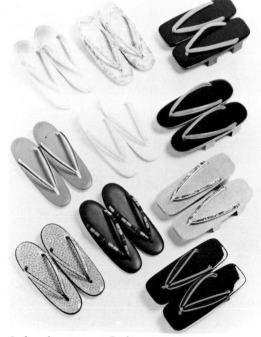

Left and center: zori. Right: geta.

Accessories

DATE ERI

The *date eri* is a vestige of the old custom of wearing two kimono at the same time, the inner kimono with a collar matching the color of the outer kimono. The modern *date eri* is a separate collar worn to accent the kimono neckline in a matching or contrasting color.

These collars are made of crepe, satin or Shioze silk. Some are colored without designs, others dyed with shading, and some have small patterns. A color lighter or darker than the color of the kimono is usually chosen. The *date eri* may be worn with the *furisode, hōmongi, tsukesage, iro muji* and *komon* kimono.

Date eri.

OBI ITA

The obi *ita* (obi stay) is inserted between the obi and the kimono and serves to keep the kimono from becoming wrinkled. It is 30 to 60 cm. long.

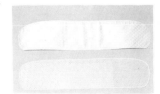

Obi *ita.*

OBI MAKURA

The obi *makura* (obi pad) is used to shape the tied bow. A thick pad is worn by young women, a thinner one by older women. There are different kinds of pads, depending on the shape of the bow, and the cords are tied in front.

Obi *makura.*

OBI-AGE

To cover the obi *makura* and hold the obi crest line in place, there is the obi-*age*, or bustle sash. It is tied in front and the ends tucked into the top of the obi. The fabric may be crepe, satin, silk, nylon or acetate. They are available in a variety of designs including full and partial tie-dyes, shaded tie-dyes and small patterns.

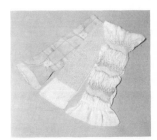

Obi-*age.*

OBI-JIME

The obi-*jime*, a cord tied at the front of the obi, accents the beauty of both obi and kimono. It is either braided or sewn. The yarn for braided obi cords is made especially for this purpose, and the cords may be round, flat or square. Silk, satin or gold brocade are used for the sewn cords. The sewn cord, such as gold brocade, is the first choice with ceremonial kimono.

Obi-*jime.*

OBI-DOME

The obi-*dome* is a brooch for decorating the front of the obi. It is attached to a cord (about a centimeter wide) narrower than the obi-*jime* and of a color matching the base color of the kimono. The cord is slipped through loops on the brooch and tied in back under the bow.

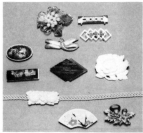

Obi-*dome.*

Kimono brooches are fashioned from diamonds and other jewels, coral, tortoise shell, cloisonné, ceramics and so on. They can be worn to parties and formal gatherings but should never be worn at a tea ceremony or a funeral.

HAIR ORNAMENTS

Ornamental combs and hairpins are placed in the hair to highlight the hairdo. Jewels, lacquer, silver or tortoise shell are used to make combs; beads of coral, jade or tortoise shell to make hairpins.

PURSES

Since large bulky purses are not appropriate when wearing the kimono, the kimono purse is generally much smaller than the ones carried when wearing western clothes. Purses without straps are considered more dressy than purses with straps. Many materials are used. In particular, a purse made of a kimono material adds a touch of gentleness to a woman's appearance. It is most suitable with a spun silk or wool kimono.

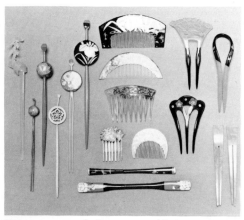

Hair ornaments. *Left*: ornamental hairpins. *Center*: ornamental combs. *Bottom center*: ornamental hair bars. *Right*: hairpins.

Handbags. *Clockwise from upper right: Miyabi kago*, an elegant cord-tied bag on a bamboo frame. *Kinchaku*, a cloth bag closed with cords. *Furoshiki*, rectangular cloths used to wrap and carry things. *Sukiya-bukuro*, a bag for carrying small necessary things when going, for example, to a tea ceremony. Western-style purses with and without straps.

The Obi

Obi Development

Obi textiles are extremely varied. There are woven obi and dyed obi, and colors range from relatively simple single colors to gorgeous creations of the textile maker's art. Widths vary somewhat, and the ways of tieing the obi number in the hundreds, with new bows being invented even today.

The history of the obi as a decorative element in kimono wear dates from early modern times, that is, during the Edo period. Until the Sengoku period (1482–1558) the obi was a thin blindstitched cord. It was functional, merely serving to tie the *kosode* kimono and keep it from becoming disarranged.

The obi that shows the transition from the thin cord-obi to the flat woven obi is the Nagoya obi (different from the present-day Nagoya obi; see *figure 24*, p. 38). This Nagoya obi was popular in the Momoyama and Edo periods and was like the braided or plaited cord of today. The cord obi was wound around the waist three or four times, and the only decoration was a tassel of 14–15 cm. The wide but comparatively short kimono of those days did not have deep sleeves like the *furisode,* so a wide obi was not necessary.

From the middle of the Edo period when the *kosode* kimono took on the form it has today, obi for women became wide too. Prior to this both men and women had tied the obi at the side, in back or in front depending on personal choice. Then fashions changed and the obi was tied in front, like those seen in *ukiyo-e* prints. Later unmarried women tied their obi in back and married women in front.

One important influence on the obi bow came from Kabuki actors who would appear on stage with their obi tied in a new way. These innovations were made much of by ordinary townspeople, and many exist today, two examples being the *tateya* (standing arrow) and *chidori* (plover) bows.

It was also during the middle of the Edo period that the form of the obi like that of today emerged, the measurements being 3.6 m. in length and 26.8 cm. in width.

While there are now only two types of obi for men—the *kaku* obi, which is stiff, and the *heko* obi, which is soft—there is a wide choice of obi for women.

One of the most basic distinctions is the way in which the obi is patterned. There are obi without any pattern, and there are *zentsū* and *rokutsū* obi. *Zentsū* are fully patterned from end to end and depending on the type may be patterned on both sides. *Rokutsū* obi have sixty percent of the total length of the obi patterned. The patterned areas are the part of the obi that shows in front or the part that is tied into a bow in back.

Figures 1, 2 and *3* show three representative obi and their parts: the fully patterned *maru* obi, the sixty percent patterned *fukuro* (double-fold) obi and the sixty percent patterned Nagoya obi.

1. MARU OBI

1. *Tesaki* or *taresake*—Short or trail section.
2. *Oridashi sen*—Edge of woven section..
Note: Either end may be short or trail section.

2. FUKURO OBI

1. *Tesaki*—Short section.
2. *Dōmawari*—Waist (front) section.
3. *Rokutsu gara*—Sixty percent patterned section.
4. *Taresaki*—Trail section.
5. *Oridashi sen*—Edge of woven section.

3. NAGOYA OBI

1. *Tesaki*—Short section.
2. *Dōmawari*—Waist (front) section.
3. *Otaiko*—Drum section.
4. *Taresaki*—Trail section.

Obi Bows

The number of ways of tieing the obi into a bow is very large, from three to five hundred, so only a few representative examples can be presented here.

The names of bows reflect a number of inspirations. As mentioned earlier, the *taiko* bow takes its name from a bridge, Taiko-bashi. The parts of this very common bow are shown in *figure 4*.

Another drum bow is the double drum (*niju-daiko*) bow. Worn by married women on ceremonial occasions, its name signifies the doubling of one's joy.

A bow for unmarried women, worn on ceremonial occasions, looks like a sparrow with its wings spread. It has been given the name plump sparrow (*fukura suzume*) bow.

The *fukuju so* bow is named after a grass (*so*): A*mur adonis*. This is also a double meaning in that *fukuju* means prosperity and longevity.

A number of bows are shown in *figures 1–12*, pp. 26–27.

4. DRUM BOW

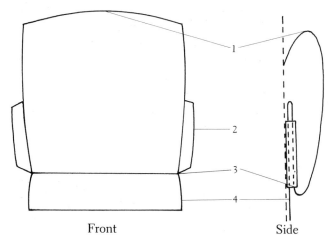

Front Side

1. *Obi yama*—Crest line. 3. *Kime sen*—Fixed fold line.
2. *Tesaki*—Edge of short section. 4. *Tare*—Trail section.

Kinds of Obi

The classification of obi is based on the way in which they are made and has a relation to the occasions on which they are worn. Fabrics, colors and designs are varied, some being appropriate for a particular season, some for married women, some for single women and so on. (*See also* p. 25.)

MARU OBI

Made of brocade, this fully patterned obi is the most elegant and most formal of obi. Double the width of an ordinary obi, it

is folded in two lengthwise and sewn over a stiff lining.

Traditionally the *maru* obi was worn with such formal attire as the five crested *tomesode*, the *furisode* and the *hōmongi* kimono. Now it is seldom worn with the *tomesode* but is often to be seen on special ceremonial occasions, primarily in combination with the bridal *furisode* and the bride's after-the-ceremony kimono.

FUKURO OBI

The *fukuro* (double-fold) obi ranks next to the *maru* obi. It is appropriate for formal and semiformal occasions.

When this obi is woven in the form of a tube, it is called *hon-bukuro*, the "real double-fold" obi. When the back and the front are woven separately and then sewn together, it is referred to as *nui-bukuro*, "sewn double-fold" obi. Nowadays the double-fold obi is usually of the latter type. As a rule, only the front of the obi is decorated, either fully patterned or sixty percent patterned, and the reverse side is left plain.

NAGOYA OBI

First produced at the end of the Taishō period (1912–26) in Nagoya, and hence the name, this obi is simpler and lighter than the double-fold obi. There are woven and dyed Nagoya obi. The woven (*ori*) obi is made of silk gauze damask. The dyed (*some*) obi is made of dyed silk gauze. The *ori* Nagoya obi ranks slightly higher, but both are acceptable for a variety of occasions, depending on the material and the design.

A third type of Nagoya obi is black and white and is worn with mourning kimono.

FUKURO NAGOYA OBI

This obi is a combination of the double-fold obi and the Nagoya obi. It is also referred to as the cross-stitch (*kagari*) obi because it is made by cross-stitching the selvages. This obi is lightweight and easy to wear, either in town or for informal gatherings. Depending on the material and design, it can also be semiformal wear.

ODORI OBI

The *odori* obi is the longest obi. It is designed, as its name indicates, to go with the special kimono worn for performances of Japanese dances (*odori*) but may also be worn with ceremonial or semiformal kimono.

HARAAWASE OBI

The *haraawase* is a lined obi made by sewing together two pieces of cloth over a stiff lining. Width may vary slightly with individual taste.

It was worn for almost all non-formal occasions during the

Meiji and early Taishō periods. Especially popular was the lined *chūya* (day and night) obi, so called from the combination of bright and dark colors. It is rarely seen today but might be worn when going to the theater.

HITOE OBI

Hitoe means one layer, and the *hitoe* obi is an unlined woven obi. Available in various widths, it is worn with an unlined kimono during the warm months from late May through September. Because it has no stiff lining, it goes well with a casual kimono or a *yukata*.

HAN HABA OBI

Half the width (*han haba*) of other obi, this obi is sewn over a stiff lining. It is suitable for wear under the *haori* or with a kimono when relaxing at home. *Han haba* obi for winter are made of wool, but since it is not double layered, it can also be used with summer *yukata*.

TSUKE OBI

Designed for those who desire the convenience of a ready-made Nagoya obi tied in a *taiko* bow, this modern invention consists of a front part and a bow part, which can be easily fitted together. It can be worn with casual kimono or town wear. There are also ready-made obi tied in the plump sparrow bow.

The following chart summarizes the representative types of obi and the occasions for which they are appropriate.

TYPES OF OBI

Obi	Width	Length	Occasion
Maru	32 cm.	420 cm.	Ceremonial, wedding
Fukuro	30 cm.	420 cm.	Ceremonial, formal
Nagoya	30 cm.	360 cm.	Casual, in town
Fukuro Nagoya	30 cm.	360 cm.	Traveling, casual
Odori	31 cm.	450 cm.	Ceremonial
Haraawase	31 cm.	420 cm.	Other than ceremonial or formal
Hitoe	30 cm. 23 cm. 15 cm.	390 cm. 320 cm. 320 cm.	Traveling, summer festival, casual
Han haba	15 cm.	320– 360 cm.	Casual, children's wear

Putting on Kimono and Obi

Preparation

Putting on the kimono and obi can be done most conveniently if all the necessary items are laid out beforehand within easy reach. In addition you will need needle and thread to sew the half-collar to the collar of the under-kimono.

1. *Tabi*—Split-toed socks
2. *Hadajuban*—Undershirt
3. *Susoyoke*—Half-slip
4. Towels or body pads
5. *Nagajuban*—Full-length under-kimono
6. *Han eri*—Half-collar
7. *Eri shin*—Half-collar lining
8. *Chikara nuno*—Collar adjustment
9. *Date-jime* or *date-maki*—Waistband or under-sash
10. *Koshi himo*—Sash
11. Kimono belt
12. Obi
13. *Kari himo*—Temporary cord
14. Obi *ita*—Obi stay
15. Obi *makura*—Obi pad
16. Obi-*age*—Bustle sash
17. Obi-*jime*—Obi cord
18. *Zōri*—Sandals

Half-collar

Before putting on the under-kimono it is necessary to sew the half-collar (*han eri*) to it. A stiff cotton lining (*eri shin*) is often used when attaching the half-collar to the under-kimono.

At this time the *chikara nuno* should also be sewn to the under-kimono. The *chikara nuno* (collar adjustment) is a wide rectangle (10×41 cm.) of cloth with three loops attached to it (see *figure 2*, p. 76). The collar adjustment hangs from the neck along the back mid seam. By passing the collar cords of the under-kimono through one of the loops, the opening of the under-kimono at the nape can be adjusted.

To attach the half-collar:

1. Fold the upper and lower edges of the half-collar over the lining and sew along the top and bottom edges.

2. Determine the midpoint of the half-collar. Place the midpoint on the back seam of the under-kimono. Align the edge of the half-collar with the bottom edge of the under-kimono collar and pin it in place. Sew the half-collar along the outside edge of the under-kimono collar.

3. Fold the half-collar over the collar of the under-kimono. Sew the neck part of the half-collar to the bottom edge of the under-kimono collar. The lower ends of the half-collar are left unsewn on the inside so that the half-collar can be adjusted to show the proper amount.

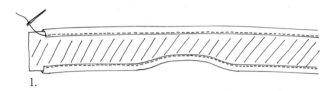

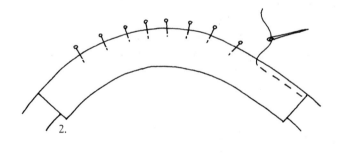

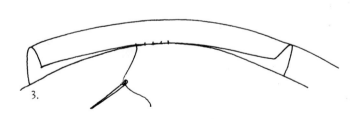

Tabi

Tabi should be fitted to the feet before putting on the under-shirt and half-slip. Putting on *tabi* after putting on the kimono is difficult and causes the kimono to lose its shape.

To put on the *tabi*, fold the back part over the front, slip in your toes, then unfold the back part and fasten the hooks at the ankle.

Putting on *tabi*.

Undershirt and Half-slip

The undershirt (*hadajuban*) and half-slip (*susoyoke*) are worn directly over your bra and pants. The collar of the undershirt should not fit tightly and it should not show under the under-kimono collar. The hem of the half-slip should be just long enough to hide the tops of the *tabi*.

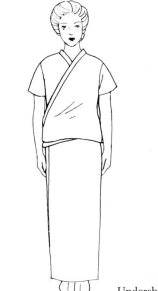

Undershirt and half-slip.

Body Pads

Since the kimono is cut and sewn in straight lines, it may be necessary to modify your body shape to preserve the kimono's natural, smooth flowing, cylindrical outline. The areas to be dealt with are the hollows around the collar bone, the stomach, the waist, the hips and the breasts. As already mentioned, the kimono brassiere is designed to suppress the bust line. Concaves in the body's outline can be adjusted by using pads or thin towels.

1. After putting on the undershirt and half-slip, first fill in the hollows around the collar bone. This can be done with cotton wool or small thin towels. Long thin Japanese towels are ideal for this purpose, and pads or undershirts with padding are also available.

2. The small of the back can be filled with towels folded to follow the contours of your body and kept in place with sashes.

3. Two or three towels sewn together do nicely to fill in the space below the breasts.

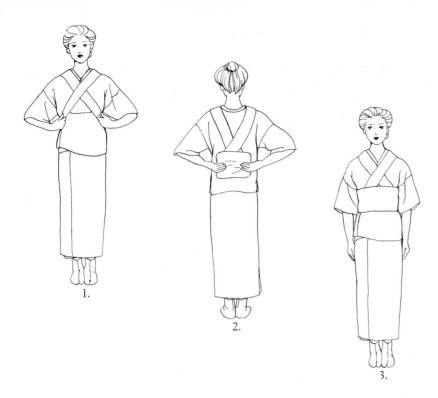

1.

2.

3.

Full-length Under-kimono

The full-length under-kimono (*nagajuban*) is put on after the undershirt and the half-slip and after making adjustments in the body shape.

When putting on the under-kimono, be sure to leave an opening about the size of your fist at the nape. Fold the under-kimono left over right and arrange the front collar panels so that the opening at the neckline measures the width of three fingers. The hollow places at the base of the neck should not be visible.

1–2. Take the cords attached to the collar ends (the one on the inner collar panel passes through the left armhole) and pass them through one of the loops on the collar adjustment (*chikara nuno*). The bottom loop is often the one that gives the appropriate opening at the nape. Bring the cords to the front and reverse their direction. Then tie these cords in back.

3. To adjust the inner collar panel, pull gently on the collar end with your left hand, so that the inner panel drapes smoothly over the waist and hips. Pull and adjust the outer panel in the same way. If the under-kimono is too long, it should be gathered and folded over (or sewn) at the waistline. Reach around to your back and straighten the center seam.

4. Set the waistband (*date-jime*) or under-sash (*date-maki*) at the back of the waistline. Once the under-kimono has been properly adjusted back and front, fasten the waistband or under-sash in front.

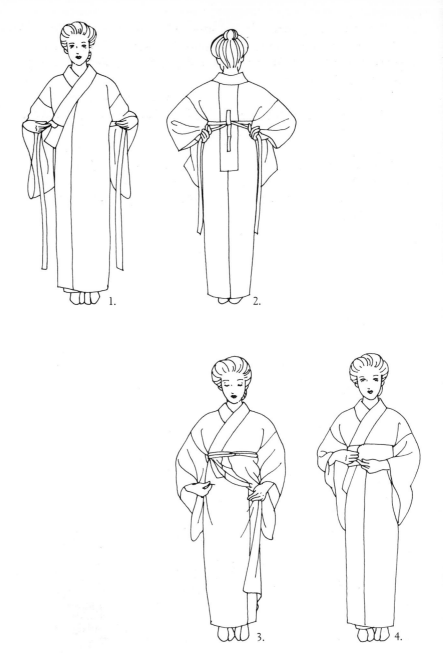

EASY-TO-WEAR SLIP AND PADS

For women wearing the kimono for the first time, there are easy-to-wear slips and pads. These make the preliminary body adjustments easier to accomplish, and they are convenient because they have separate collars and half-sleeves, which are the parts of the undergarments most likely to become soiled.

The kimono slip is worn exactly like the full-length underkimono. It has pockets in which pads can be placed to adjust the shape of the body.

1. After putting on the kimono slip, pass the cords attached to the collar ends through one of the loops of the collar adjustment, leaving the proper opening of the collar at the nape (about one fist width).

2. Bring the cords to the front, pass them through the loops on the collar ends, pull the collar ends down, and tie the cords.

3. After making sure that the opening at the front neckline is adjusted properly (about three finger widths), tie the short cords attached to the collar. This is only to keep the collar ends from moving to the sides, so the cords should not be tied too tightly.

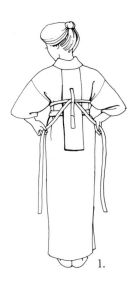

1.

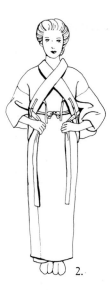

2.

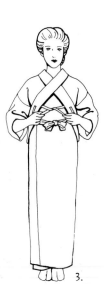

3.

4. Place pads at the small of the back to fill in the concave above the hipline and create the smooth lines necessary to wear the kimono well. Put on the elastic waistband. This is to press in the waist, if necessary, and keep it firm.

5. The waistband should pass over the collar ends to hold them in place.

6. Half-sleeves for this kimono slip are attached with magic tape, creating an appearance that looks no different from the regular full-length under-kimono.

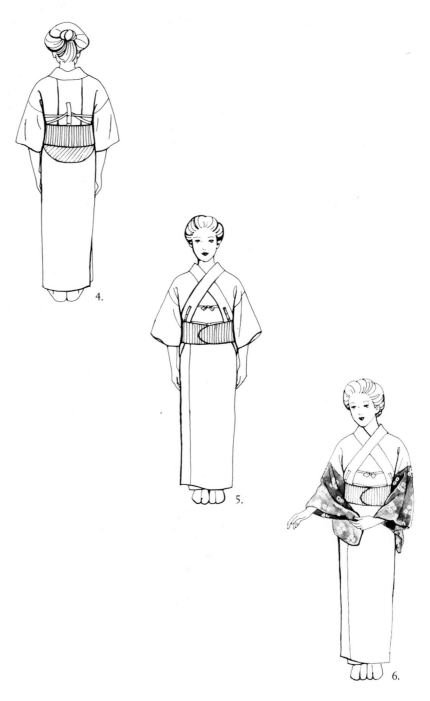

Kimono

With the under-kimono or kimono slip firmly in place, you are now ready to put on the kimono itself.

1. Standing with your back straight, bring the left and right collar ends together. The back mid seam of the kimono should be directly in line with the middle of your back. To keep the back panel in place, temporarily clip the collar of the kimono to the collar of the under-kimono with a clothespin.

2. With your right hand pull the collar ends directly out in front of you. Take the back mid seam with your left hand and raise the kimono off the floor. Then lower the kimono hem until it is just even with the floor.

3. To determine the width of the outer kimono panel, hold the right kimono panel away from your body and wrap the left (outer) panel around your body until the left collar end is at a point directly under your right armpit.

4. While gently holding the left (outer) panel out to the front, wrap the right (inner) panel around your body. The hem of the inner panel should be raised about 15 cm. from the floor. Any excess material should be neatly gathered and folded above the left hip.

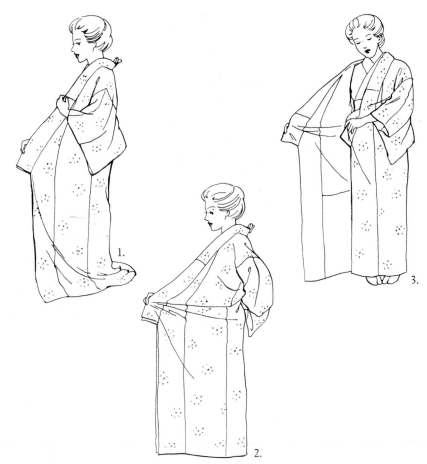

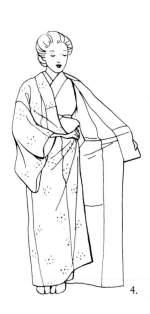

5. Wrap the outer panel over the inner panel. Make sure that the outer collar end comes just to the point directly under your right armpit. The hem of the outer panel should be raised slightly less than half (6–6.5 cm.) the distance the inner panel hem is above the floor. After the kimono has been folded over at the waist, the wrinkles should be smoothed out by pulling to the sides and the excess material adjusted on both sides by making tucks going toward the back.

6. When both panels are correctly positioned, tie a *koshi himo* sash 2–3 cm. above the waistline to hold them in place.

7. Place your left hand through the left armhole and smooth out the kimono from back to front, making any necessary tucks. Do the same in front with the outer panel. Arrange the bottom line of the tuck in front so that it is straight and neat.

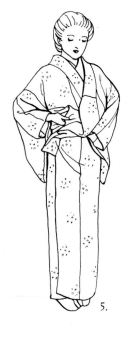

5.

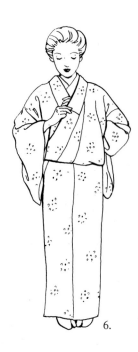

6.

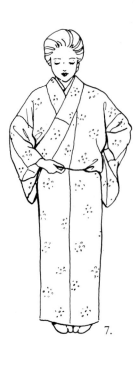

7.

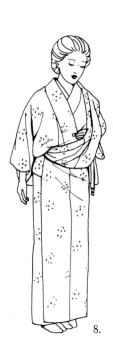

8.

8. Check to see that the front collar of the under-kimono shows properly. Then clip one end of the elastic kimono belt, which is about a shoulder width in length, to the inner panel just above the waist.

9. After arranging the tuck at the right, wrap the kimono belt around the back and fasten the other end to the outer panel.

10. Any wrinkles in back should be taken in with tucks and pushed toward the openings under the sleeves.

11. The excess material under the sleeve openings should now be gathered at the right side and tucked inside the outer panel.

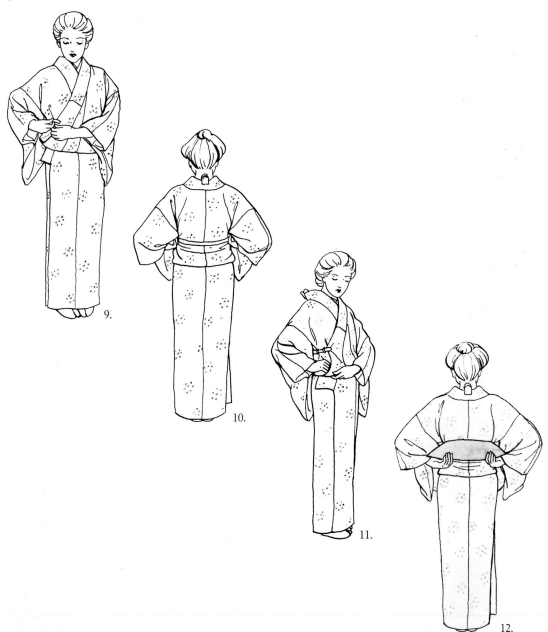

9.

10.

11.

12.

12. Set the waistband (*date-jime*) along the waistline in back.

13. Bring the waistband to the front. The excess material under the bosom should be pushed to the sides before fastening the waistband with its magic tape.

14. Fastening the waistband completes putting on the kimono.

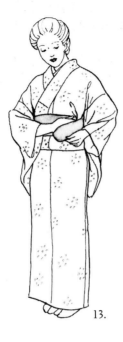

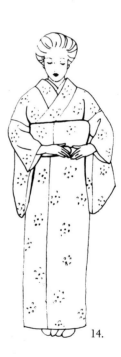

13.

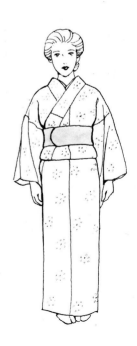

14.

Obi

NAGOYA OBI

Before tieing the Nagoya obi, refer to *figure* 3, p. 67, and note which end is the *te*, or short section, and which end is the *tare*, or trail section. Note also that with a fully patterned obi of uniform length, either end may be short section or trail section.

1. Drape the short section (*te*) over the point of your left shoulder from back to front. The folded edge of the obi faces downward, the unfolded edge toward your head.

2. The long trail section (*tare*) of the obi is wrapped around the waist twice. After the first time around, insert the obi stay (obi *ita*) in front.

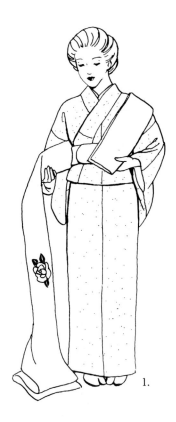

1.

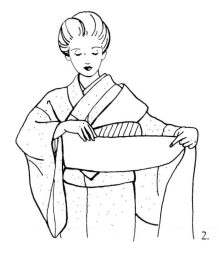

2.

3. Hold the obi by the folded bottom edge and pull it taut. This leaves the upper folded edge loose enough to allow you to breathe freely and wear your kimono and obi in comfort.

4. Lower the short section as shown in the illustration. Make sure that it is free of wrinkles.

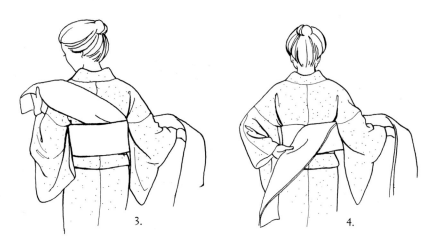

5. With your left index finger, determine where the short section meets the bottom of the obi in back.

6. Raise the trail section over your right shoulder, folding the short section into a triangle at the same time. Tie the temporary sash (*kari himo*) along the upper part of the obi.

7. Allow the trail section to drop. Measure off about 80 cm. from the end of the trail section. Make a fold here to create the drum crest. If the obi has a drum bow design, the design should be fully visible and centered in back. The drum crest at this time is usually about 20 cm. below the temporary sash.

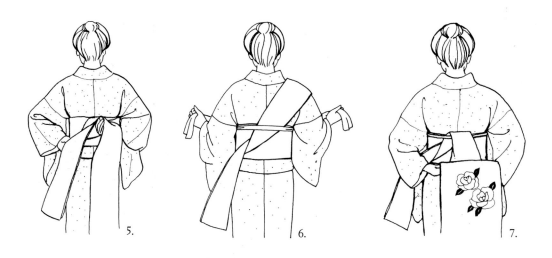

8. Center the obi pad (obi *makura*) under the drum crest line. Then while holding the obi pad with your left hand, straighten and flatten the inner fold.

9. Raise the drum part of the bow onto your back.

10. Pull the straps of the obi pad forward and then downward. Tie them in front, tucking the knot into the top of the obi.

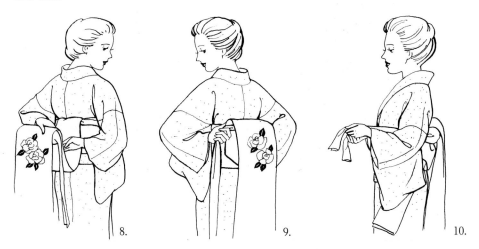

8. 9. 10.

11. Raise the trail section to your right shoulder and smooth the obi under the obi pad. Pull and straighten the triangular part of the short section hanging below the obi pad. Cover the obi pad with the bustle sash (obi-*age*) and tie it temporarily in front.

12. Lower the trail section. To determine the size of the drum, extend both arms downward and take hold of the trail section where your fingers touch it.

13. Raise and fold the trail section as shown in the illustration.

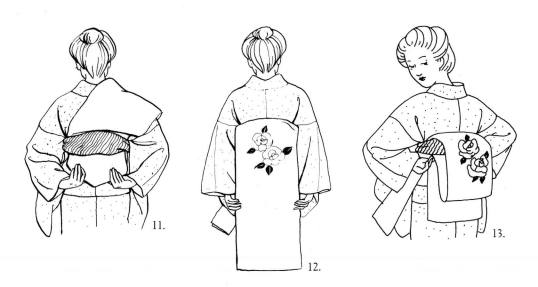

11. 12. 13.

14. Now that the size of the drum is set, adjust the end of the trail section so that it hangs about the length of an index finger (7 cm.) below the obi itself.

15. With your left hand pass the short section through the drum itself. To preserve the shape of the drum, slip your right hand into the drum to support it.

16. Smooth out the short section and tuck it neatly into the drum.

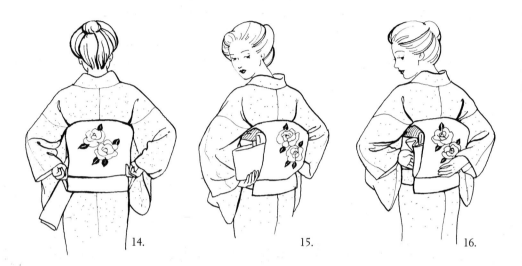

14. 15. 16.

17. Pass the obi cord (obi-*jime*) through the drum and tie it in front, according to the instructions given below. The last step is to tie the bustle sash (obi-*age*) properly, instructions for which are also given below.

18. Married women usually set the drum crest line slightly lower than do single women, and the obi pad they use is smaller than the one used by single women.

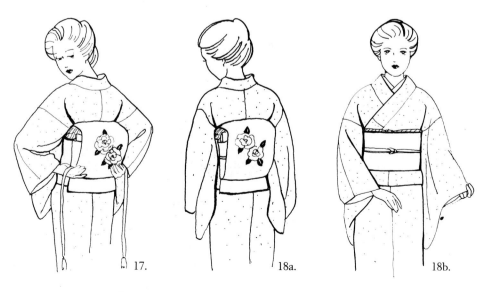

17. 18a. 18b.

OBI CORD

To tie the obi cord (obi-*jime*):

1. With the ends of the obi cord in front, make sure that both ends are the same length. Cross the ends left over right.

2. Tie and keep the knot tight with your finger.

3. Make a loop with the upper cord end.

4. Bend the other end up, and while holding the first knot tight, pass the cord through the loop.

5. Pull both ends and tighten the finished knot.

6. Tucking the left cord up from below and the right cord down from above, pull the ends to the sides.

7. Married women usually tie the obi cord just below the center line of the obi. Single women tie it directly along the center line.

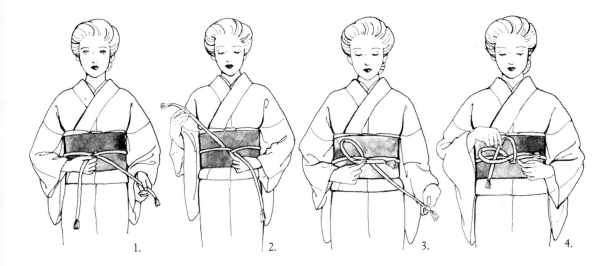

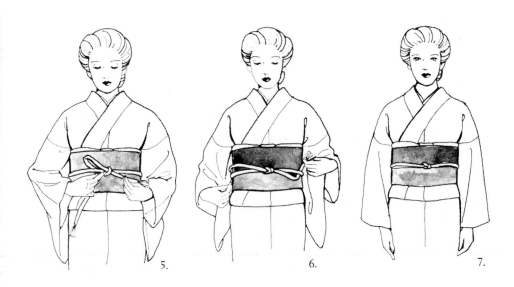

BUSTLE SASH

To tie the bustle sash (obi-*age*):

1. After untieing the temporary knot, make the width of the bustle sash one third its original width by folding one third of the outer edge upward and inward as shown in the illustration. The fold is at the top.

2. Make sure both ends are of equal length and cross the left end over the right end.

3. Pull the left end up to your left shoulder.

4. Lower the left end and smooth out the wrinkles.

5. Fold the right end into the letter L and with the left end tie a bow as shown in the illustration.

6. Place your left index finger in the loop and pull the left end.

7. Tuck the loose ends into the bustle sash.

8. Tuck the bustle sash into the obi so that it accents the upper line of the obi. Single women traditionally display the bustle sash more prominently, while married women usually tuck it a little lower into the obi.

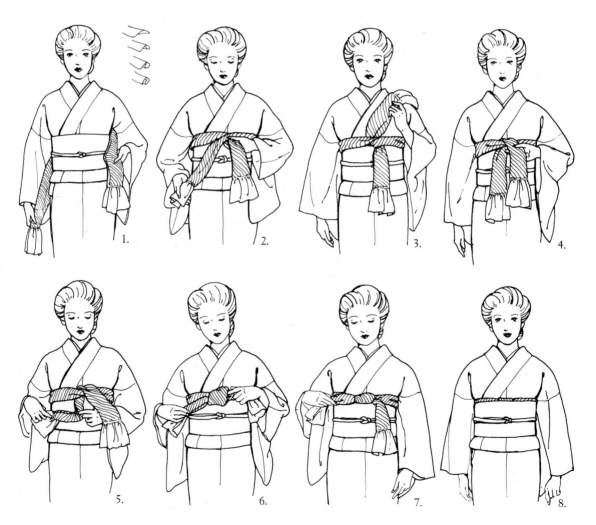

HALF-WIDTH OBI

In tieing the half-width (*han haba*) obi, it is first necessary to decide which will be the short, and which the trail, section. The bow given here is the shellfish bow (*kai no kuchi musubi*).

1. To determine the short section, measure from one end (*tesaki*) a length approximately three times the width of the obi itself. Center this point on the back seam and raise the short section over the left shoulder. The remainder, the trail section, is wrapped twice around the body.

2. Fold the excess length of the trail section up and under, so that it is 5–7 cm. longer than the short section. Fold the short section in half lengthwise.

3. Tie the obi, pulling the trail section up to your right shoulder.

4. Lower the trail section. Smooth out the wrinkles in the knot.

5. Unfold the short section so that the reverse side shows. Measure off the short section so that 3 cm. are below the bottom of the obi.

6. Fold the trail section obliquely toward the left.

7. Pass the short section through the loop made by the trail section.

8. This completes tieing the shellfish bow. This bow may also be tied in front and brought around to the back.

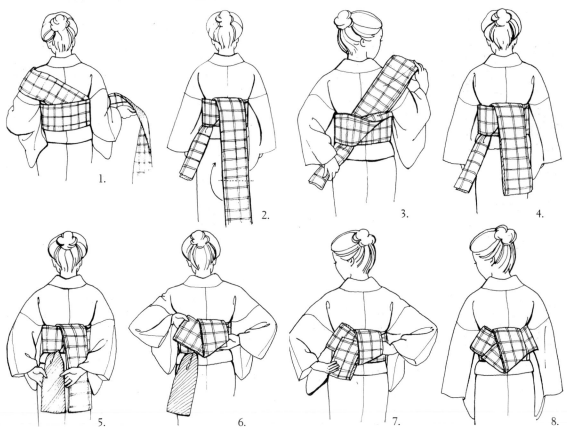

1. 2. 3. 4.

5. 6. 7. 8.

EVERYDAY OBI

An obi made of easy-to-wear elastic material is available for everyday wear. To tie this obi:

1. Make one end longer than the other. Then wrap the obi lightly around the waist.

2. Tie the obi once in back as shown in the illustration.

3. Fold the longer end obliquely to the left and pass the shorter end through the loop.

4. Shape the bow by pulling both wings.

5. The completed bow is neat and will not slip out of place. It can also be tied in front and brought around to the back.

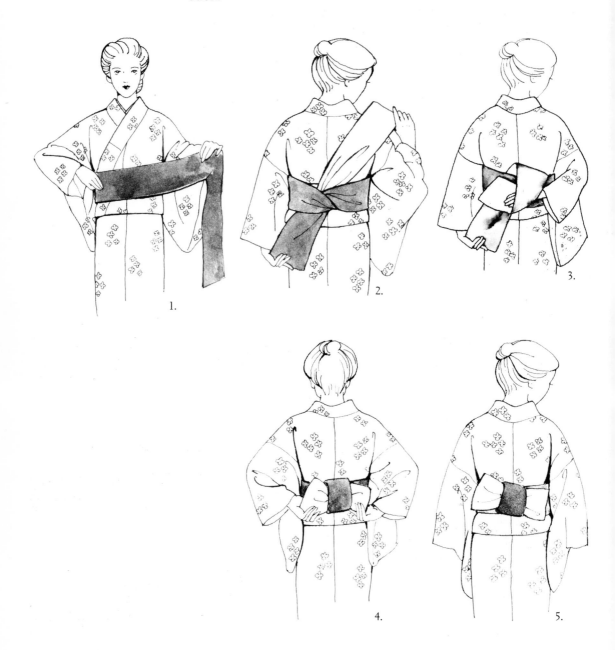

1.

2.

3.

4.

5.

MAGIC OBI AID

In recent years a number of new devices have been invented to make the wearing of the kimono and the tieing of the obi easier and less time consuming. One of these devices is called the magic obi aid.

The obi aid and its parts are shown in *figure* A. Have the bustle sash (obi-*age*) as well as the obi ready at hand. The obi is sixty percent patterned and the bow is the plump sparrow (*fukura suzume*) bow.

 1. Fold the obi into accordian folds with the trail section on top.

 2. Measure off 70 cm. from the end of the trail section (*taresaki*) and attach a clothespin. This part becomes the drum part of the bow. Then make box pleats as shown in *figures 2a–c*. Fold over one third, then fold back, leaving about 1 cm. protruding beyond the folded edge. The clothespin should be at the center of the box pleats.

A. MAGIC OBI AID

Front Back

1. Pad A.
2. Elastic tape.
3. Upper tape.
4. Open slit clamp.
5. Lower tape.
6. Snap.
7. Elastic tape.
8. Tape stopper.
9. Drum clip.
10. Pad B.

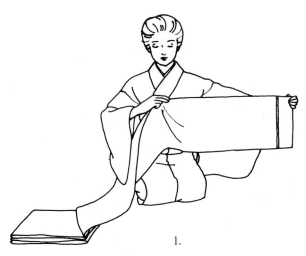

1.

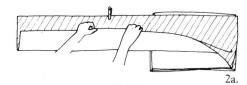

2a.

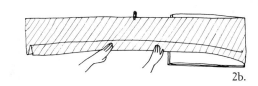

2b.

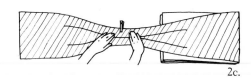

2c.

3. Place the obi aid in the middle of the box pleats, face up, with the obi aid pad even with the clothespin and pointing to the left (toward the trail section).

4. Holding the obi aid with the right hand, fold the trail section over the obi aid with the left hand.

5. Turn the obi aid over and fasten the obi in place with the elastic tape on the back of the obi aid.

6. Turn the obi aid over again so that the trail section is on top. Then fold the trail section toward you.

7. Fold the trail section away from you leaving the obi aid exposed.

8. Fold half of the trail section back toward the obi aid. Pass the obi through the open slit in the middle of the obi aid.

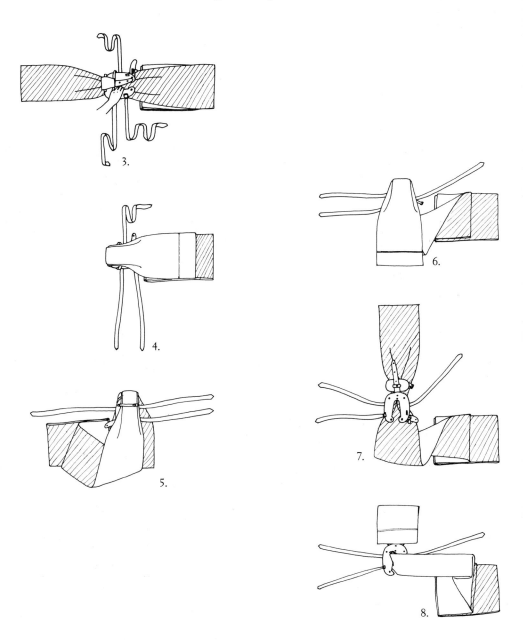

3.

4.

5.

6.

7.

8.

9. Fasten the snap at the bottom back of the obi aid.

10. Fold the main part of the obi using accordian pleats. Then place the obi on top of the obi aid.

11. Unfold the obi to the right as far as the second pattern-ed section. Lift where the design and the plain sections meet and place the plain section underneath.

12. Starting from the right end, measure off the main part of the obi (waist size plus 25 cm.). Adjust the length of the two parts of the obi to the left of the snap. The upper one (about 50 cm.) will become the left wing of the bow. The lower one (about 40 cm.) will become the right wing.

13. Unfold the trail section, exposing the obi aid. Close the obi aid and fasten it. Attach the tape stopper to the right end of the obi.

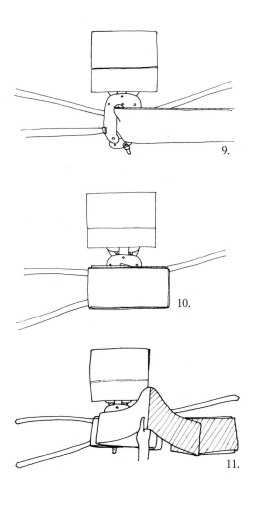

9.

10.

11.

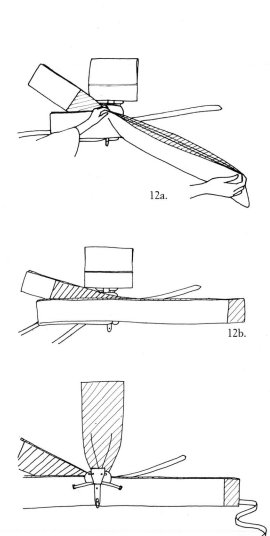

12a.

12b.

13.

14. Unfold the upper (left) wing lengthwise and fold over 20 cm.

15. At the point nearest the obi aid, fold the left wing to make three crests of the same height as shown in *figures 15a–b*.

16. Fasten the left wing with the elastic tape.

17. Bring the lower (right) wing in front of you and unfold it.

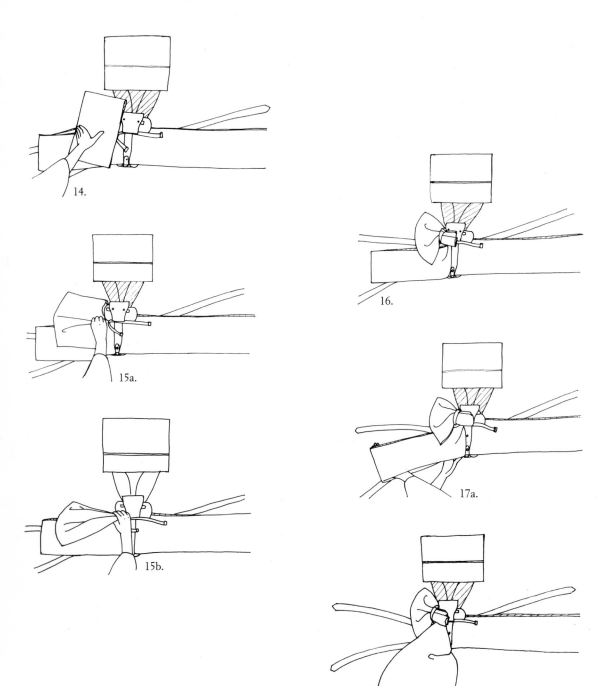

14.

15a.

15b.

16.

17a.

17b.

18. Shape the right wing into three crests of equal height and fasten it with the elastic tape.

19. Fold the excess material of the right bow over toward the right tape.

20. Pass the bustle sash through the pad at the top of the obi aid.

21. Cover the obi aid with the trail section.

22. Fold the excess length of the trail section up and under, leaving 7–8 cm. of the trail section below the bottom of the obi. Fasten the right side of the trail section with a drum clip (*figure 22b*). Do the same on the left side.

23. Shape the bow. The completed plump sparrow bow and its parts are shown in *figure 23* (*overleaf*).

Note: When tieing a fully patterned obi, steps 13, 14 and 15 are unnecessary. Arrange the obi to allow 85 cm. for the main part, 50 cm. for the left wing and 40 cm. for the right wing.

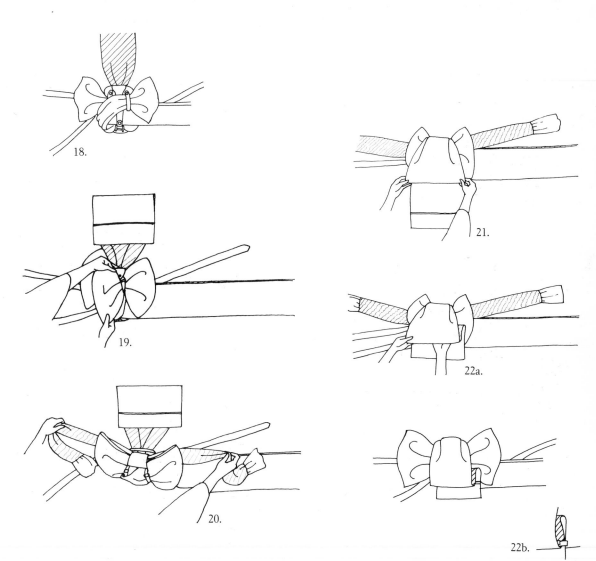

18.

19.

20.

21.

22a.

22b.

PLUMP SPARROW BOW

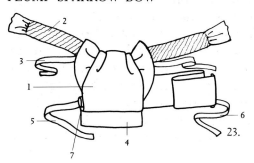

1. Drum.
2. Bustle sash.
3. Upper tape.
4. Trail section.
5. Lower tape.
6. Tape stopper.
7. Drum clip.

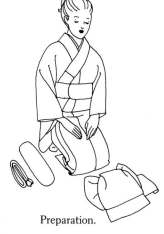

Preparation.

To put on the obi tied in the plump sparrow bow with the magic obi aid, arrange the obi, along with the obi stay and obi cord, in front of you as shown in the illustration.

1. Hold the obi aid with your right hand as shown in the illustration. Then balance it on your right arm. This makes it easy to move the completed bow to your back.

2. Insert the obi aid under the waistband (*date-jime*) from the top.

3. Take the upper tapes and tie them at the front. The drum part of the bow should fit close to your back. Tie the bustle sash temporarily in front.

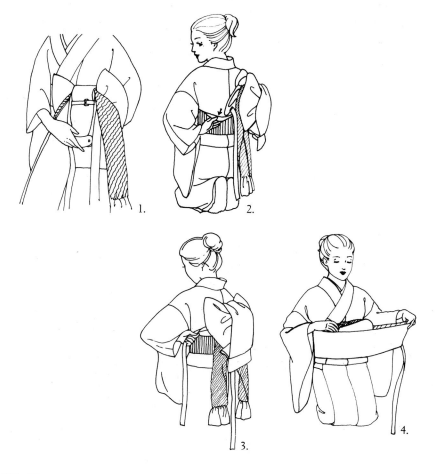

1.

2.

3.

4.

4. Insert the obi stay in the front section of the obi and adjust the width of the obi according to your waist size.

5. Lift the bow and clip it to your collar. Bring the tape stopper to the left side of the obi aid. Hold the tape stopper and the clamp in the middle of the obi aid with your left hand and tighten the obi. Bring any excess length to the left and fold it in.

6. Cross the tapes, placing the tape stopper on the lower tape, then tie them. Tuck the knot under your obi.

7. Lower the bow and place the obi cord at the lower fold as shown in *figures 7a–b.*

8. Adjust the drum by smoothing it out to the sides. Bring the ends of the obi cord to the front and tie it. (*See* p. 87.)

9. Adjust the wings of the bow. Then remove the drum clips and tie the bustle sash. (*See* p. 88.)

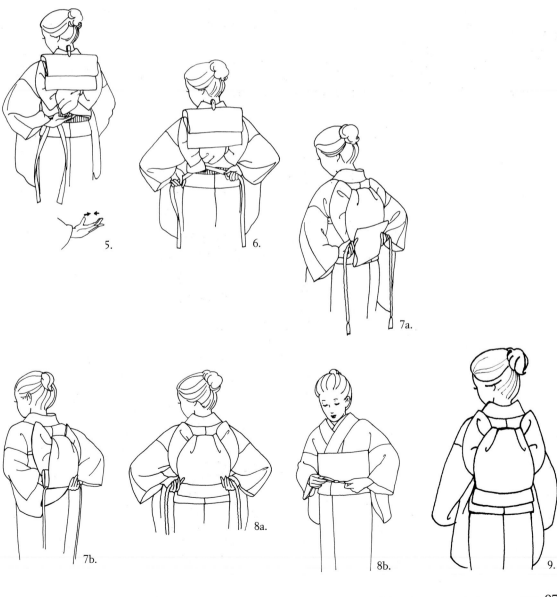

5.

6.

7a.

7b.

8a.

8b.

9.

Proper Kimono Appearance

The following are important points to be carefully observed to wear the kimono properly and well.

For the single woman:

1. About 2 cm. of the under-kimono collar should show beneath the kimono collar at the front neckline.

2. Conceal the under-kimono collar at the nape about 5 mm. below the collar of the kimono.

3. Adjust the kimono neckline to hide the collar bones.

4. The kimono neckline at the nape should be pulled back the width of three fingers and shaped to look like the letter V.

5. Raise the hem of the inner kimono panel about 15 cm. from the floor.

6. The outer kimono panel should be raised 6–6.5 cm. from the floor.

7. The kimono tuck under the obi should be about the length of an index finger. Make sure the bottom fold of the tuck is straight.

8. In comparison with married women, the obi is worn slightly higher.

9. In tucking the bustle sash into the top of the obi, make it puff up slightly.

10. Make sure the knot of the obi cord is in the middle of the obi.

11. Single women use a larger obi pad than married women and position the obi crest line slightly higher.

12. The edge of the obi trail section should be about the length of an index finger below the obi itself.

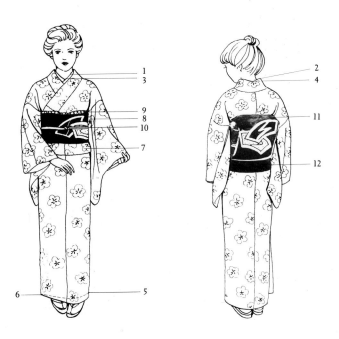

For the married woman:

1. About 1.5–2 cm. of the collar of the under-kimono should show at the neckline beneath the kimono collar.

2. The opening at the neckline should be approximately the width of three fingers.

3. The opening of the collar at the nape should be rounded into the shape of the letter U.

4. Raise the hem of the inner kimono panel about 15 cm. from the floor.

5. The outer kimono panel should be raised 6–6.5 cm. from the floor.

6. Married women position the obi slightly lower than do single women.

7. Do not allow the bustle sash to show too prominently.

8. The obi cord should be tied the width of the cord below the center line of the obi.

9. In comparison with unmarried women, the obi pad is smaller and the obi crest line is slightly lower.

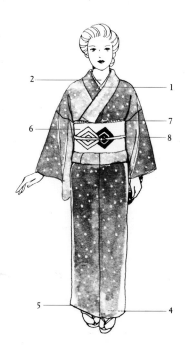

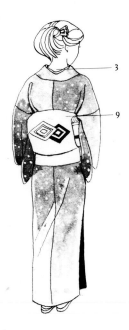

When wearing the *yukata*, observe the following points.

1. Close the front neckline as much as possible.

2. Do not let the collar at the nape open too much.

3. Take care not to make the tuck under the obi too long and be sure that the bottom fold of the tuck is neat and straight.

4. Raise the hem of the outer kimono panel half as high (4–5 cm.) as the hem of the inner kimono panel (8 cm.).

5. Let the hemline fall naturally and keep it even with the ankles.

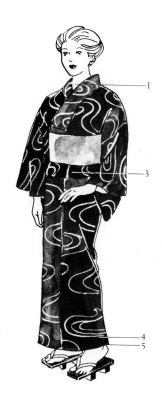

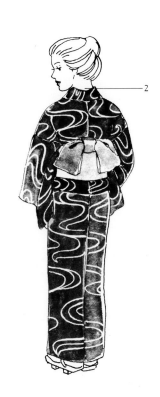

Kimono for Men and Children

Kimono for Men

Kimono for men are on the whole more subdued in color than women's kimono. A man will choose his kimono carefully, however, according to whether the occasion is ceremonial, formal or informal.

For ceremonial occasions there is the black, crested kimono (*kuro montsuki*) worn with the *haori* and the long pleated skirt known as a *hakama*. Both the kimono and *haori* are made of black *habutae* silk and have the five family crests: on the back of both sleeves, on the left and right breast and high on the back mid seam. The *haori* cords are white.

The full-length under-kimono is made of dyed *habutae* silk without patterns, and the collar attached to the under-kimono may be either white or gray.

The obi is the stiff (*kaku*) obi.

The *hakama* is made of striped Sendai *hira* silk.

White *tabi*, split-toed socks made of cotton calico, are worn with *zōri*, which have a design of either white or black stripes.

The white folding fan that completes the ensemble is held in the hand or inserted in the *hakama*.

On formal occasions, kimono and *haori* made of unpatterned spun silk are worn. The *haori*, which has a single crest on the back mid seam, either matches the color of the kimono or contrasts—lighter or darker—with the kimono color. The *haori* cords should match the base color of the kimono and the *haori*.

The full-length under-kimono is often made of material with small patterns (*komon* or Edo *komon*). The inner collar may be white, gray or brown.

The *kaku* obi is tied at the waist, and *zōri* with either black or white stripes are worn with either black or white *tabi*.

Kimono of either spun silk or wool are chosen for informal occasions. If the material is spun silk, the kimono and *haori* are of the same color. The color and pattern of the full-length under-kimono may be chosen according to individual taste, but the inner collar and *haori* cords should be of a slightly different shade from the color of the kimono.

The obi is the *kaku* obi.

Tabi of dark blue are worn with either *zōri* or *geta* (raised wooden sandals).

For the hot summer months a cotton *yukata*, worn without an under-kimono, makes a very comfortable garment. The soft (*heko*) obi is worn, and *geta*, rather than *zōri*.

Putting on Kimono and Haori

UNDERGARMENTS

1. To wear the kimono properly, some men may find it desirable to first put on a padded vest. This will insure a natural and smooth line over the stomach and will facilitate the tieing of the obi and the wearing of the *hakama*.

2. In putting on the under-kimono, stretch both panels out to the front, making them of equal length. The mid seam in back should be aligned with the center of your back. Wrap the panels left over right. Place the waistband around your waist and fasten it in front with the magic tape.

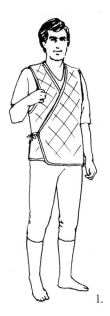

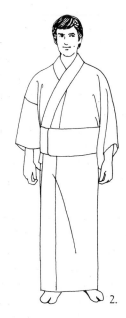

KIMONO

1. Bring the left and right collar ends together to align the back mid seam with the center of your back.

2. Determine the width of the outer (left) kimono panel first by gently pulling it in a straight line to your right hip.

3. Determine the width of the inner (right) panel by pulling the collar end to your left hip.

4. With the inner panel set at the left hip, bring the outer panel to the right hip. While gently holding the outer collar

end, straighten the seam on the left side. The attached collar of the under-kimono should extend about a centimeter above the kimono collar.

5. To straighten the sides, pull them down, placing the hands on the hips. While holding the collar end on one side, pull back the seam on the other side so as to smooth out any wrinkles.

6. For the sake of convenience, a sash may be used to keep the kimono in place while tieing the obi. If a sash is used, it should be tied so that it is slightly raised in back.

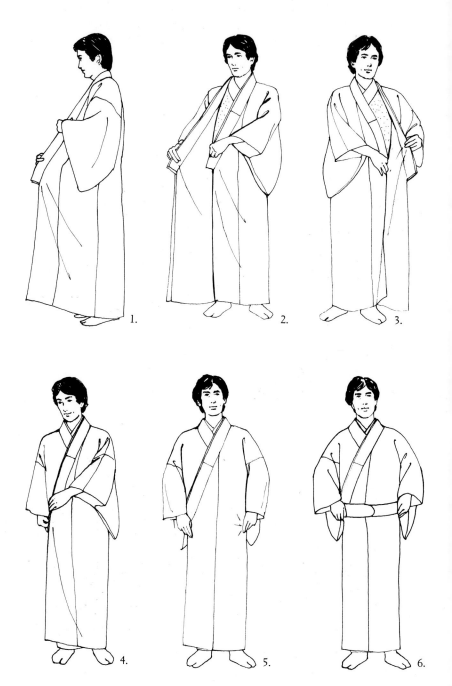

THE STIFF OBI

The following is the way to tie the shellfish bow with the stiff (*kaku*) obi. First choose one end of the obi to be used for the short section (*te*).

1. Fold the short section in half lengthwise and hold it about a fist's width from the end. While holding the short section (raised slightly), wrap the obi tightly two or three times around your waist.

2. Holding the obi with your arm fully extended, fold in the excess length.

3. Wrap the trail section of the obi and pull it tight with the right hand. Tighten the obi further by pulling on both ends.

4. The short section and trail section should be of equal length.

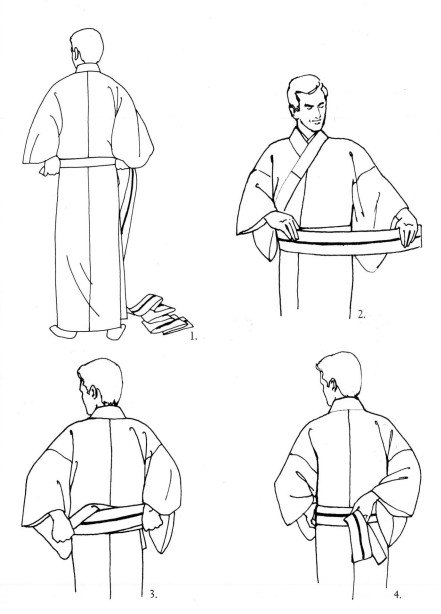

5. Fold the short section down and cross the trail section over it.

6. Pass the trail section under the short section and pull it up.

7. Fold the short section up toward your right shoulder.

8. Lower the trail section and slip it through the loop made by the short section.

9. Finish tieing the bow by pulling both ends. The trail section is aligned with the obi and the short section is pointing towards your right shoulder. Neither end should be too long.

10. If the obi is tied too tightly, the kimono will become gathered at the waist.

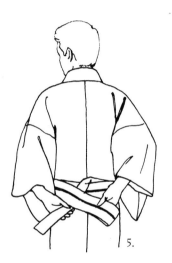

5.

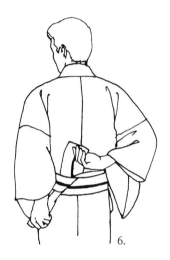

6.

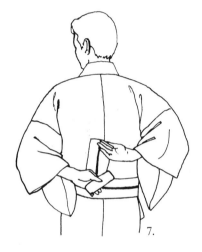

7.

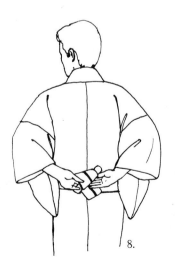

8.

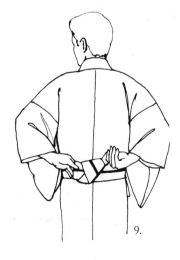

9.

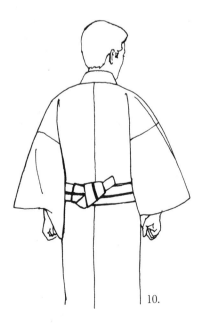

10.

READY-TO-WEAR STIFF OBI

This obi has a ready-made shellfish bow and may be adjusted to any waist size.

1. Adjust the length of the obi and hook the clamps.
2. Pull the bow to the right.
3. The completed obi in back looks as if the bow was tied with the regular stiff obi.

Stiff obi.

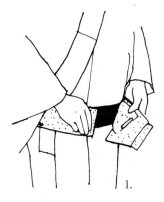

1.

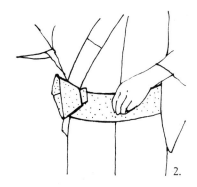

2.

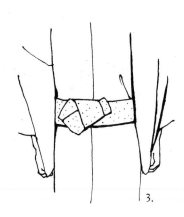

3.

THE SOFT OBI

To tie the soft (*heko*) obi for wear with the *yukata*:

1. First make the obi the appropriate width by folding it lengthwise. Fold both edges toward the center, then fold again. Then measure off about 70 cm. from the center of your back to form the short section. Keep this end slightly raised while wrapping the rest of the obi two or three times around your waist.

2. Pass the short section under the trail section and tie it in a knot.

3. Make a loop with the trail section.

4. Pass the short section through the loop and tie the obi into a bow.

5. Both loops are of the same size and the knot itself should not dangle below the obi.

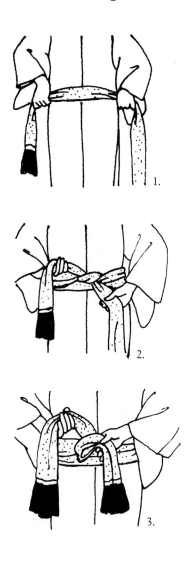

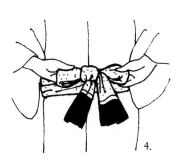

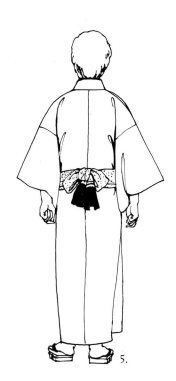

PROPER KIMONO APPEARANCE

Before putting on the *haori* and *hakama*, check the appearance of the kimono from the front and from the side.

Front:

1. The collar should be arranged neatly and naturally.

2. The obi rests on the hipbones and comes slightly below the stomach.

3. The bottom of the inner panel should be about 1 cm. above the outer panel.

Side:

1. The collars of the under-kimono and kimono are worn close to the nape of the neck.

2. The obi bow should be tied neatly, with the back of the obi raised slightly higher than the front.

3. The hemline should be even with the ankle bones.

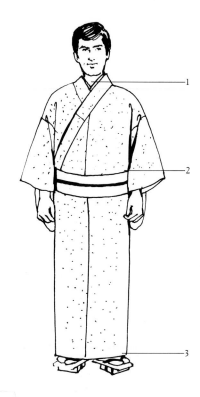

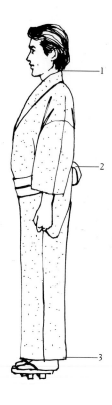

HAORI CORDS

After putting on the *haori,* tie the cords in front as follows:

1. Make two loops as shown in the illustration.
2. Place one loop on top of the other.
3. Fold the tips of the cords down over the loops.
4. First let the tassels fall freely, then pull the cords through the loops so that the tassels are at the top.
5. Tighten the cords, forming a knot with the tassels stopped at the knot.

Haori cords with the knot already tied are also available.

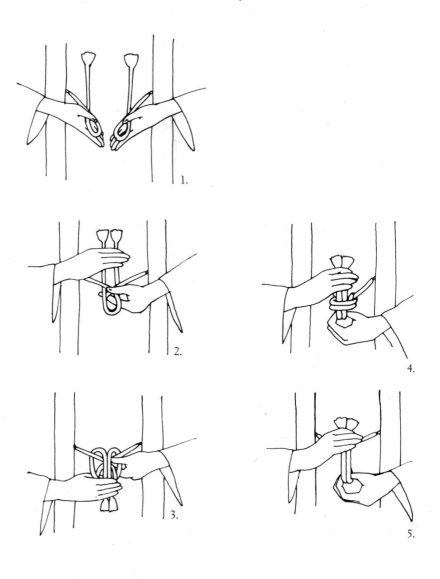

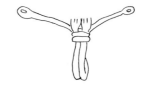

Putting on the Hakama

The *hakama* and its parts are shown in *figures* A (front) and B (back).

A–B. HAKAMA

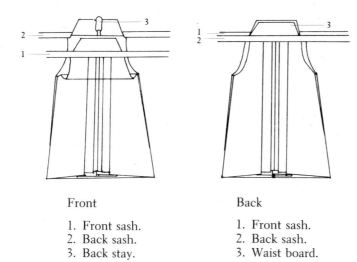

Front

1. Front sash.
2. Back sash.
3. Back stay.

Back

1. Front sash.
2. Back sash.
3. Waist board.

 1. Position the front sash 1–2 cm. below the upper edge of the obi and bring the two ends around to the back.

 2. Cross the ends below the obi bow and return them to the front.

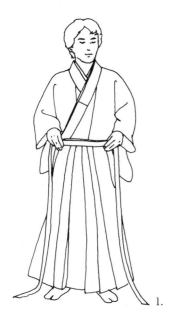

1.

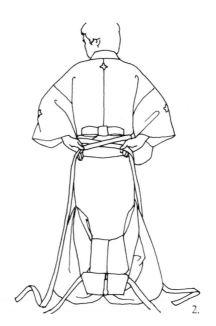

2.

3. Cross the sash held in your left hand under the one in your right hand in front of the left hip.

4. Fold the sash in your left hand upward over the lower edge of the other sash. (This keeps the place where the sashes cross from moving toward the center.)

5. Bring the ends to the back and tie them in a bow knot below the obi bow.

6. Insert the back stay of the *hakama* between the kimono and the obi from the top.

7. When the waist board has been properly centered in back, bring the back sashes to the front.

8. Cross the ends of the back sash in front, left over right.

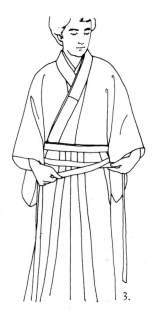

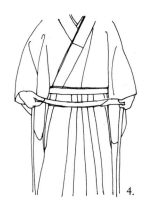

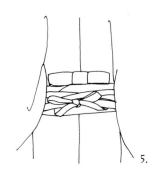

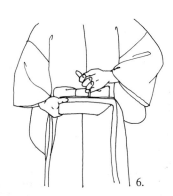

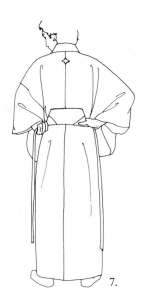

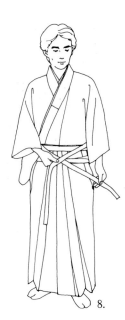

9. Hold both sashes with the right hand and use the left hand to pass the ends of the back sash under the lower section of the front sash (*figure 9a*) and pull them down tight (*figure 9b*).

10. Wrap the left back sash over the right back sash and the lower section of the front sash.

11. Center the two ends in front where they cross.

12. Bring the right end over to the left side and raise the left end up. (The end that was in your left hand is now in your right hand and vice versa.)

13. Again pass the sash in your right hand under the lower section of the front sash.

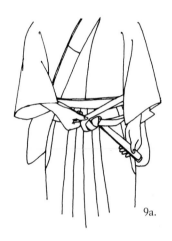

9a.

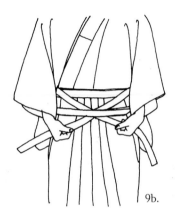

9b.

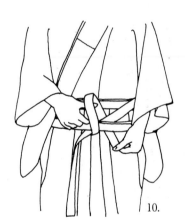

10.

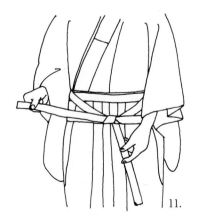

11.

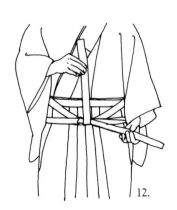

12.

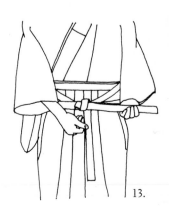

13.

14. To make the horizontal bar, bring the left end to the right. Then fold inward to make it one third of its former length. Center the horizontal bar.

15. Bring the other end upward over the horizontal bar.

16. Pass this end under the lower section of the front sash.

17. Bring the lower end up. Then pass it in back of the lower sash again, leaving a loop at the top. Now fold the lower end upward, tucking it under the lower sash and leaving a loop at the bottom the same size as the loop at the top.

18. Shape the knot to form a cross.

19. Note that the back of the *hakama* is slightly higher than the front. Since the lower edge of the back stay is right over the obi bow, the obi will be slightly stretched.

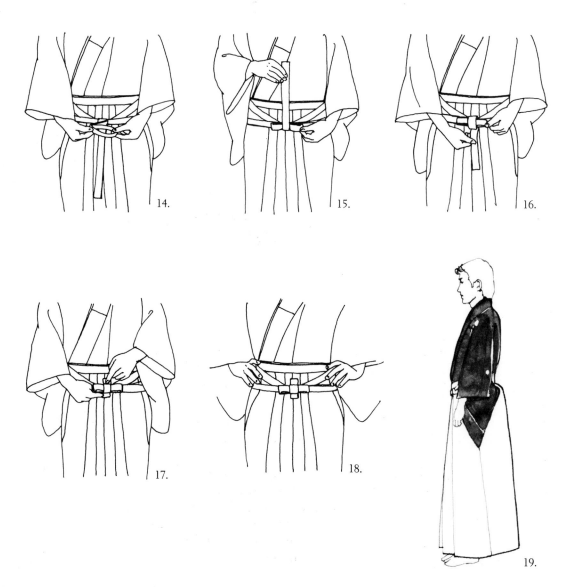

14.

15.

16.

17.

18.

19.

EASY-TO-WEAR HAKAMA

1. For those desiring the convenience of a pleated kimono skirt with the sashes already tied, there is the "ten-second" *hakama*.

2. To put on this *hakama*, first center it in front.

3. Fasten the sashes in back with the magic tape.

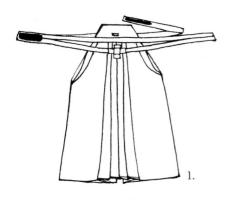

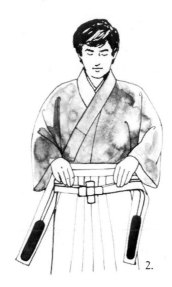

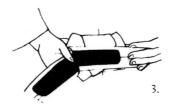

Kimono for Children

The most formal and most representative kimono for children are the ones they don for the celebration of *Shichigo-san*. Celebrated on November 15, this day has traditionally marked the passage of certain milestones in the lives of boys and girls of three (*san*), boys of five (*go*) and girls of seven (*shichi*). The numbers three, five and seven are considered to be lucky.

The custom goes back to the Genroku era (1688–1704) of the Edo period. In those days, boys and girls of three were allowed for the first time to let their hair grow long. When boys reached the age of five, there was a ceremony marking their first wearing of the *hakama*. At the age of seven, girls put aside the simple cord obi and began to wear a formal obi.

Parents of today dress their three-year-old boys in a kimono of black *habutae* silk worn over a full-length under-kimono of the same material. The *haori* is sleeveless and the *tabi* and *zōri* are white.

For the girl of three, the kimono is fully patterned Yūzen, worn over a tie-dye under-kimono with a spotted pattern. The inner collar is made of embroidered Shioze silk. With an embroidered obi 11 cm. wide and 3 m. long she wears a sewn obi cord and a red bustle sash. Footwear may be either cloth *zōri* or the *geta* known as *pokkuri.*

The five-year-old boy celebrating *Shichigosan* puts on a kimono of black *habutae* silk with a shaded pattern. The *haori* has white cords and a single family crest. The *hakama* he wears for the first time is varicolored and made of Shioze silk, or he may wear a kimono of Sendai *hira* material. The 7 cm. by 2.5 m. obi is the Hakata obi. He wears *zōri* for going outdoors.

When a girl reaches the age of seven, she may be allowed to wear a five crested kimono with elaborate designs on the skirt. Or she may wear a tie-dye Yūzen with a spotted design. The colored under-kimono is of a woven fabric and it is patterned. Tied at the waist in back is an embroidered obi. Cloth *zōri* are worn, or *pokkuri geta* made of paulownia with figured brocade straps. (*See also* p. 21.)

Kimono Care

Cleaning

A kimono of fine quality silk requires special care to keep it clean and free from stains. An important, but often neglected, precaution is simply to wash one's hands before putting the kimono on and before taking it off. Stains on the hands, particularly from oily toilet articles, are immediately transferred to the kimono and will quickly attract moths and other insects. Neck, arms and feet should also be clean before putting on a kimono.

When going out it is advisable to carry three handkerchiefs. One of lace makes an attractive accessory when sitting and it keeps one's hands from touching the kimono directly. A second large white handkerchief is suitable for spreading over the lap when eating. The third handkerchief should be large and colored. It can be used when riding in a car, to wipe stains or dirt off the kimono or to wipe the hands.

At the dining table pay close attention to the way the kimono sleeves move. It is a good idea when reaching for something to restrain the movement of the sleeve with your free hand.

When walking outside be careful not to soil the hem of the kimono. When it is raining walk carefully and avoid splashing mud on the skirt. Raindrops can leave stains that are difficult to remove, so it is best to wear a full-length raincoat that will protect the kimono completely.

Air the kimono before putting it away. This is done best with a pole long enough to allow the sleeves to be fully extended to the sides. Hanging the kimono in a cool airy place lets the moisture and body heat escape and also smoothes out wrinkles. When brushing dust off the collar, shoulder and skirt, do so in the direction of the weave.

In removing stains from the collar, sleeve ends and skirt, spread a white towel on your lap and place these parts on it. Lightly tap the soiled area with gauze soaked in benzine. Benzine, however, tends to leave a stain; it is best to clean the entire area rather than try to remove just the spots.

If mud gets on the kimono, let it dry thoroughly before brushing it off with a soft brush. Then gently rub the soiled area with a small piece of velvet in the direction of the weave.

The obi should also be aired before being put away. If it is a woven obi, smooth out the wrinkles by ironing on the reverse side of the obi. Cotton and synthetic obi can be sprayed and ironed.

Folding

The kimono is cut in straight lines and can be easily and neatly folded into a square. Folding it properly takes out most of the creases and keeps the kimono looking neat and clean. An improperly folded kimono will show the unnecessary creases.

The first rule is to fold the kimono correctly along the seams. Bring the corners together neatly and fold section by section. The secret lies in preserving the long vertical lines and not making needless horizontal creases.

Placing the folded kimono in a paper wrapping case.

The traditional material for closets and storage chests has since ancient times been paulownia. It was used first for clothing and later for pictures, books and curios. Paulownia, by expanding and contracting in response to outside temperature and humidity, maintains a constant temperature and humidity inside the storage space.

UNDER-KIMONO

1. Spread the under-kimono flat with the front upward and the collar to your left. Fold the right side inward first, then the left side, bringing the collar ends together.

2. Fold the collar downward.

3. Fold the right side over to the center and the right sleeve completely inward. Then fold the right sleeve end back to the right side.

4. Do the same with the left side. Fold the left side to the center, the left sleeve inward and then fold the left sleeve end outward to the left side.

5. Fold in half, bottom over top.

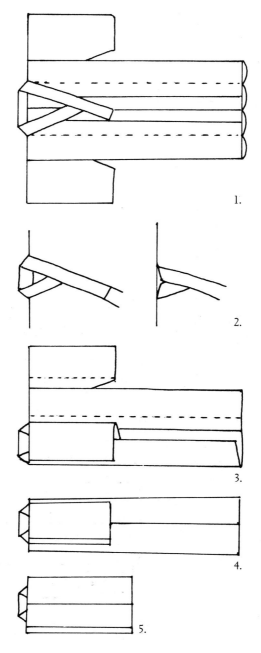

1.

2.

3.

4.

5.

KIMONO

1. Spread the kimono out in front of you with the collar to your left. Fold the outer (left) panel so that the collar end is fully extended to the side away from you.

2. Fold the inner (right) panel along the gore. The reverse side of the gore should now be facing up. The folded seam extends from the shoulder at the collar to the hem. Make sure the fold is directly on the seam.

3. Fold the top edge of the collar down and tuck it in.

4. Gently pull the outer panel over the folded gore of the inner panel. This fold should be directly along the side below the armhole. Make sure that both gores and both collar ends are lined up.

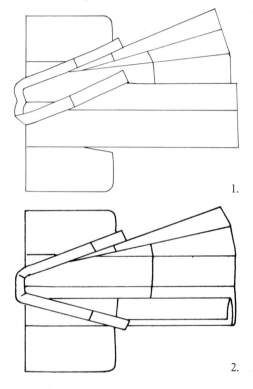

1.

2.

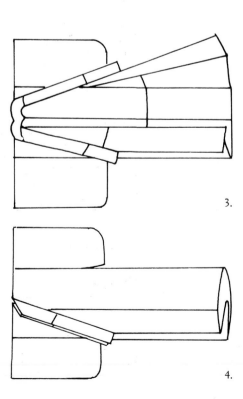

3.

4.

5. Bring the seams on the sides together and cover the right sleeve with the left.

6. Fold back the upper sleeve.

7. Fold the bottom half of the kimono over the top half. Be careful not to fold the collar ends while doing this.

8. Turn the kimono over so the collar is to your right. Fold in the right sleeve and the kimono is ready to be put away. If a paper kimono wrapping case is used, the collar should be placed on the left.

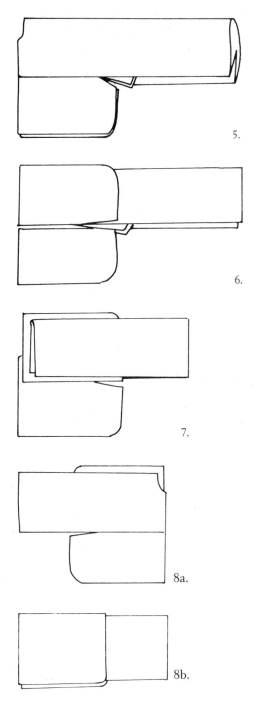

5.

6.

7.

8a.

8b.

HAORI

1. Spread the *haori* out with the collar to your left. Fold the panel nearest you back from the center. Let the *haori* cords rest away from the center. Fold the top of the collar neatly downward.

2. Place the collar ends left over right.

3. Bring the edge of the left panel over the right one. Place the left sleeve over the right one.

4. Fold back the upper sleeve.

5. Turn the *haori* over. Fold the other sleeve inward.

6. Fold the bottom of the *haori* over the sleeves. As with the kimono, if a paper wrapping case is used, the collar goes to the left.

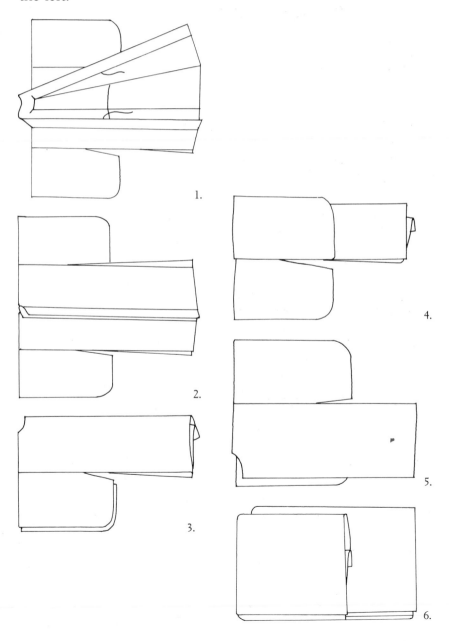

1.

2.

3.

4.

5.

6.

OBI

DOUBLE-FOLD OBI

1. First fold the obi in half.
2. Fold the obi in accordian folds. The length becomes one third of the original. Place cloth or paper between the folds to prevent sharp creases.

DOUBLE-FOLD NAGOYA OBI

1. Lay the obi face downward with the double part (the drum section) in front of you. At the inner edge of the drum section, bring the edges together and fold downward to make this end of the drum section triangular. Fold the rest of the obi in half lengthwise.
2. Lay the folded long part of the obi back along the bottom half of the drum section.
3. Fold the long section upward at the point where the drum section ends.
4. Lay the folded long section along the top of the drum section. It will be longer than the drum section. Fold the excess length back toward the center. The obi is then ready to be put away.

Kimono Etiquette

Posture and Movement

Wearing a kimono is not simply a matter of putting it on, for it is the wearer who makes the kimono elegant or tasteless. The truth of this can be seen by imagining the same kimono being worn by two different women. One woman may appear a dazzling princess, the other like a recent arrival from the country. This is because the kimono reveals, rather than disguises, the wearer's inner qualities. There is no other garment which does so so uncompromisingly.

Posture is of great importance. It should be natural, with the back straight, the chin pulled in slightly and the shoulders relaxed. Sudden or large movements should be avoided, since they will expose the arms and, especially, the legs, and allowing even the briefest glimpse of the legs is considered quite bad taste.

The movement of the sleeves should be controlled, so that they neither drag nor swing wildly. And when walking, large hurried steps will ruin the front folds of the kimono. To walk gracefully, point your feet straight ahead but step slightly inward. Be careful not to exaggerate this inward movement, which would result in a pigeon-toed walk.

All in all, movement when wearing a kimono should be more restricted, slower and more balanced than the freer movements possible with western style clothing.

When visiting friends or relatives, try not to load yourself down with unnecessary bags or purses. Carry all your belongings in one arm. It is customary to take off outer garments before entering a house, but if the weather is cold it is permissible to keep the kimono coat on until you are inside.

When climbing stairs, keep your body erect and your weight balanced and evenly distributed. Do not raise your heels from your slippers and be careful not to allow the hem of the kimono to rise. Taking large steps will make it difficult to keep your slippers on and will open the front panels of the kimono.

When entering a house, always take off your *zōri* at the entrance foyer before stepping up into the hallway. Kneel and face the door to turn your *zōri* in the direction of the door. This will facilitate putting them on again when you are ready to leave. After your visit step down from the hallway and put on

your left *zōri* first. This will keep the kimono from opening in front.

Upon entering a *tatami* room, kneel and sit with your legs folded beneath you. When you bow to your host or hostess, do so from the waist, keeping your back straight and your hands resting lightly on the floor in front of you. (You need not lower your head overly much.) After bowing, support your weight with your fingertips and move your knees in unison to take your place on the cushion provided. The correct way to sit is with your knees together, your back straight and your big toes crossed in back. Those unaccustomed to sitting on *tatami* may find this uncomfortable at first, but with a little practice, one can sit in this position for long periods of time.

When eating and drinking, it is best to avoid reaching for things with both hands and to always use your free hand to keep the other sleeve from dragging. When drinking, use your right hand to place the cup or glass on your left palm and to keep it steady when not actually drinking.

To open the paper-covered doors known as *fusuma*, kneel on your toes as shown in *figure 8a*. Slide the door partway open with the hand nearest the outer edge of the door. Use the other hand to open the door fully.

When sitting in sofas or chairs, there is a tendency to lean back, but this will cause the kimono to become disheveled in front and the obi to lose it shape. Sit erect with your purse on your lap and your knees and feet together.

When getting into a car, do not do so head first. Place one hand on the back of the front car seat and sit on the edge of the seat. Ease one foot and then the other into the car. Bring your feet in front of you, knees and feet together.

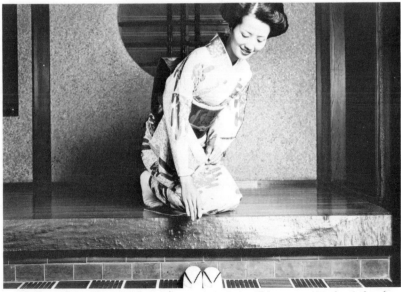

1. At the entrance foyer, arrange your *zōri* so they will be conveniently ready when you leave.

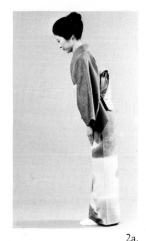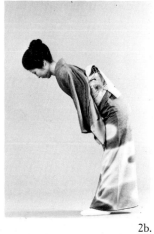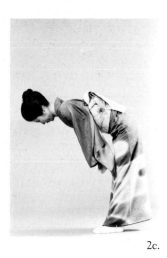

2a. 2b. 2c.

2a. When greeting friends or relatives, the bow need not be deep.

2b. The bow should be deeper when greeting an older person.

2c. A very deep bow is offered when visiting a shrine or a temple.

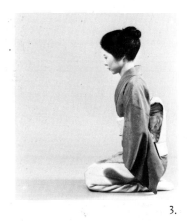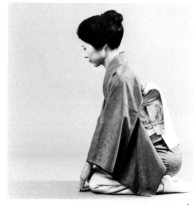

3. 4a.

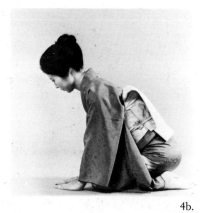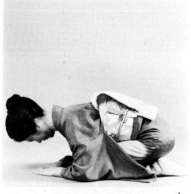

4b. 4c.

3. This is the correct way of sitting on *tatami*.

4a. Bending the head slightly forward is the way to acknowledge the presence of others.

4b. This is the most typical way of bowing while sitting on *tatami*.

4c. Very deep bows are made when showing great respect to a person or when kneeling before a family altar.

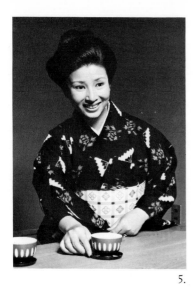

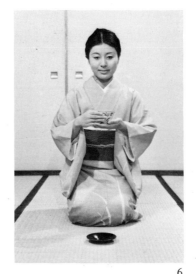

5.

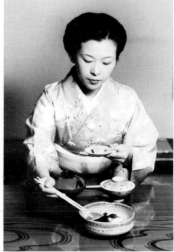

6.

7.

5. When offering tea, the other hand can be used to keep the sleeve from swinging.

6. While drinking tea or other beverages, the left hand serves as a tray to hold the cup or glass between sips.

7. Small controlled movements are necessary when eating to keep the sleeves under control.

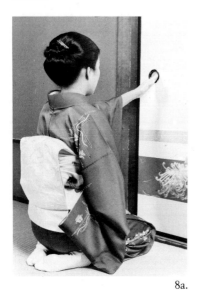

8a.

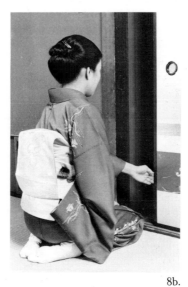

8b.

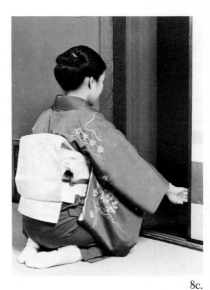

8c.

8a. To open sliding doors, first use the hand nearest the outside edge.

8b. Using the same hand, open the door partway.

8c. Use the other hand to open the door fully.

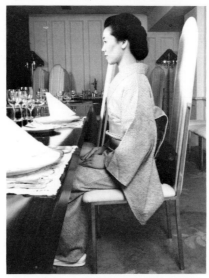

9.

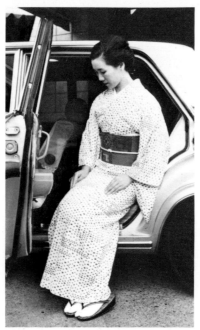

10a.

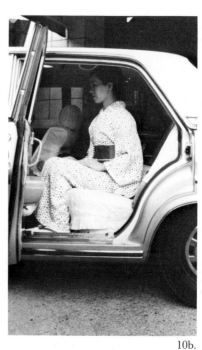

10b.

9. When sitting in a chair or sofa, it is best to keep the back straight and avoid leaning back.

10a. To get into a car, first sit on the seat. Then place one hand on the back of the front seat.

10b. Lift your feet into the car and sit straight with feet and legs together.

Appendix: The Family Crest

In the modern world the family crest is not so conspicuous as it once was. Besides formal kimono and *haori*, it appears on Buddhist altars and gravestones, on furnishings for the house and some business establishments, and occasionally figures in trademarks. It is thus with a touch of nostalgia that we look back on its long history.

Europe and Japan are the only two cultures to have a history of family crests. European heraldry dates from the twelfth century, while the Japanese crest has a longer history. Unlike heraldry, with its fixed symbols arranged in set patterns, the Japanese crest has always been essentially a design based on a single motif, sometimes simple, sometimes exquisitely complex. And, unlike the kimono, where features of basic design are known to have moved up and down the social scale, the use of the family crest filtered downward from the top.

The origins of the *kamon* go back to the Heian period, when courtiers chose emblems to embellish their carriages and household furnishings. Then, beginning in the Kamakura period samurai of rank took up the family crest. As a useful device to identify friend and foe on the battlefield, large crests in simple abstract designs were emblazoned on arms, armor and battle standards. From the daimyo the crest spread to immediate subordinates and other retainers, and from the latter part of the Kamakura period, samurai had individual family crests, a custom that continued in the Muromachi and later periods.

The widespread diffusion of these symbols of close-knit family organization took place in the middle of the Edo period, which also saw the birth of kabuki, popular literature and *ukiyo-e*. It was at this time that the crest became popular among courtesans and actors, who, as we have noted, influenced kimono fashions. Although the professional names of leading actors and even top-ranking courtesans might be passed from one generation to the next, this was not usually true of their crests. They are known, however, from books of the period. One of these, called *Kamon-zukushi*, "Collected Family Crests," was a compilation of the crests of women in Edo's Yoshiwara, a licensed quarter. Other books, such as *Edo Kagami* and *Bukan*, which were revised annually from the Kan'ei era (1614–44) to the Meiji period, were a little like a "Who's Who" and gave various information about the daimyo, along with their family crests.

During the Edo period, some townsmen and farmers had family crests, although they did not at that time always have surnames. After the Meiji Restoration (1868) everyone took a surname and anyone so inclined could use a family crest.

An interesting aspect of this history is that the makers of family crests remain unknown. It seems very likely that some were the work

of the artists who gave the world *ukiyo-e*. But a far greater number were the creations of artisans who dwelt in some quarter of Edo, neither advertising themselves nor obsessed by thoughts of wealth and honor. They were men who took pride and pleasure in their skill, so the actual creation of family crests was a work born from the modest spirit of individual craftsmen. In fact, much the same can be said about the skills and techniques of textile and kimono making, surviving examples of which are evidence of the possibility of the perfection of beauty.

Flowers and plants: 1. Plum blossom. 2. Plum blossom. 3. Wild cherry blossom. 4. Nine cherry blossoms. 5. Daffodil cluster. 6. Chrysanthemum. 7. Vine and chrysanthemum in diamond shape. 8. Lily. 9. Peach. 10 Rice grains. *Shapes*: 11. Yin-Yang ginkgo nut. 12. Cypress folding fan. 13. Hawk feather fan. *Natural and water scenes*: 14. Cloud. 15. Pair of scallop shells. *Animals, insects and birds*: 16. Crossed hawk feathers. 17. Butterfly. 18. Orchidlike butterfly. *Temples and shrines*: 19. Nanzen Temple. 20. Gasan Shrine, Yamagata Pref. 21. Hirota Shrine, Hyogo Pref. *Kabuki actors*: 22. Ichikawa Sadanji. 23. Onoe Baiko. *Collected crests*: 24. Wheel, Nabeshima family. 25. Lord Matsudaira of Kii. 26. Red bird, Imagawa family. 27. Chess piece in circle. 28. Three spools. 29. Three bridges of a musical instrument. 30. Four diamond shapes.

The number of family crests is quite large, there being about 400 basic types. Depending on the basis for further classification, some scholars recognize 7,000 to 8,000 crests, while others differentiate as many as 20,000. A branch family might, for example, have chosen a crest that resembled, but was still different from, that of the main family. The same might be true when a crest was bestowed on a retainer for meritorious service, although in this case an entirely new crest might have been designed. There were times when a certain element in a crest was used in the creation of a new crest; in other cases crests underwent a transformation to yield a composite crest. Then again, original ideas were the inspiration for a great number of crests.

In classifying crests eight categories are recognized. Many have as their motif plants or flowers. Some are based on the shape of buildings and objects, including furniture, musical instruments, tools and implements, conveyances, dress and ornaments and so on. Two other groups of designs are derived from animals, birds and insects and natural and water scenes. Geometric motifs and Sino-Japanese characters comprise another group. Three other groups reflect a slightly different point of view. These include the crests of Shinto shrines and Buddhist temples, those of actors and the so-called collected crests (*mon-zukushi*).

For all their variety, Japanese *kamon* share one characteristic. They are the refined expression of a basic design, and it is for this reason that they have come to be appreciated in other countries.

Glossary

ato-zome: textiles dyed after weaving

bara musubi: rose bow
beni hitoe: red unlined summer kimono
bingata: polychrome dyeing over stencil resist
bunko-gaeshi musubi: reverse box bow
bunko musubi: box bow

chidori musubi: plover bow
chikara nuno: collar adjustment
chirimen: crepe
chūburisode: *furisode* with medium length (90 cm.) sleeves
chū-gata: medium size stencil design for *yukata*
chūya obi: day and night obi

daimon: warrior's robe (Muromachi period)
darari-musubi: style of loosely tied obi bow (Edo period)
date eri: detachable collar
date-jime: waistband for under-kimono
date maki: under-sash
dō: way
dōbuku: short coat (Muromachi period)
dōmawari: obi waist section

eba: design, pattern
eba-zuke: pattern running over the seams
eboshi: warrior's ceremonial cap (Muromachi period)
Edo *komon*: small monochrome design
eri: collar
eri haba: collar width
eri o awaseru: to arrange collars
eri o tadasu: to straighten one's posture
erisaki: collar end
eri shin: half-collar lining
erishita: length under collar

fuji-gasane: shades of wisteria
fukuju: prosperity and longevity
fukuju so musubi: *Amur adonis* bow

fukura suzume musubi: plumb sparrow bow
fukuro mawata: silk cocoons formed into a bag shape
fukuro Nagoya obi: double-fold Nagoya obi
fukuro obi: double-fold obi
furi: waving
furi: sleeve below armhole
furisode: single woman's kimono with long flowing sleeves
furoshiki: cloth for wrapping and carrying things
fusuma: sliding doors covered with heavy paper

gara-zome: pattern dyeing
geta: raised wooden sandals

habutae: reeled silk, smooth and good quality. (*Cf. meisen*)
hadajuban: undershirt
hakama: long pleated skirt
hakkake: lining of back of kimono
hakoseko: small purse
han eri: half-collar
han haba obi: half-width obi
haniwa: hollow clay statue (Tumulus period)
haori: long, medium length or short coat
haoru: to put on
haraawase obi: lined obi made of two pieces of cloth
heko obi: soft obi
hinode-daiko musubi: sunrise drum bow
hitatare: everyday wear for warriors (Kamakura period)
hitoe: layer
hitoe obi: unlined obi
hōmongi: visiting kimono
hon-bukuro obi: real double-fold obi
honburisode: *See ōburisode*

ichime-gasa: headdress of women of samurai class (Kamakura period)
ichi monji bunko musubi: straight line box bow

iro: color

iro muji: colored patternless textile or kimono

iro tomesode: colored *tomesode* kimono

Iyo-*gasuri*: a splash pattern textile from Ehime Pref.

izaribata: seated loom

jōfu: fine linen; kimono made from same

jūni-hitoe: twelve layers

kagari obi: cross-stitch obi

kai no kuchi musubi: shellfish bow

kakae obi: narrow obi for young girls and decorative bridal wear

kaku obi: stiff obi

kamishimo: sleeveless upper garment for ceremonial wear by samurai (Edo period)

kamon: family crest

kanoko: lit., "fawn." Spotted tie-dye design.

kariginu: hunting outfit (Heian period)

kari himo: temporary sash

kariyasu: a grass from which yellow Kihachi-jō dye is made

kasa: umbrella

kasuri: splash pattern

kataginu: sleeveless upper garment of working classes (Muromachi and Momoyama periods)

kata haba: shoulder width

kata komon: small stencil design

kata Yūzen: hand-drawn Yūzen

kata-zome: stencil dyeing

ki: yellow

Kihachijō: *tsumugi* in yellow check pattern originating on Hachijō Island

kime sen: fixed fold line

kinchaku: cloth handbag with drawstrings

kiru: to wear

kofurisode: *furisode* with short (75 cm.) sleeves

komon: small design

koromogae: putting away and bringing out kimono with change of seasons

kōshi: check (lattice) pattern

koshi himo: sash

koshi-maki: style of wearing *uchikake* robe (Muromachi period)

kosode: short sleeve (kimono)

kurikoshi: fold-over sewn to adjust length

kuro: black

kuro Hachijō: black Hachijō

kuro montsuki: black and crested

kuro montsuki haori: black *haori* with family crest(s)

kuro tomesode: black *tomesode* kimono

kurume-gasuri: a splash pattern textile from Fukuoka Pref.

Kyō Yūzen: Kyoto Yūzen

mae haba: front width

mae migoro: front of body section

mae sode: front of sleeve

maru obi: fully patterned brocade obi

matsu-gasane: shades of pine

meisen: reeled silk, comparatively rough and strong. (*Cf. habutae*)

michiyuki: three-quarter length travel coat

mitake: length from shoulder to hem

miyabi kago: cloth handbag on bamboo frame with drawstrings

miyatsuguchi: opening under armhole

mo: long pleated skirt (Tumulus period)

mofuku: mourning wear

mono: thing

mon rinzu: figured satin

muji: patternless

muji-zome: patternless monochrome dyeing

musubi: knot, bow

nagajuban: full-length under-kimono

Nagoya obi: braided cord obi (Muromachi and Edo periods)

Nagoya obi: obi first made in Nagoya during Taishō period

naru bunka: a culture in which things become

niju-daiko musubi: double drum bow

nōshi: less formal wear of court nobles (Heian period)

nui-bukuro obi: sewn double-fold obi

obi-*age*: bustle sash

obi-*dome*: obi brooch

obi *ita*: obi stay

obi-*jime*: obi cord

obi *makura*: obi pad

obi *yama*: crest line of obi bow

ōburisode: *furisode* with long (105 cm.) sleeves

odori obi: dance obi

ōgi-daiko musubi: drum bow with fan

okumi: front panel below collar end

okumi haba: width of front panel below collar end

omeshi: heavy silk crepe

oridashi sen: edge of woven section of obi

orime tadashisa: straight correct folding

ori obi: woven obi

ōsode: large sleeve

otaiko: drum section of obi bow

otaiko dōmawari: drum bow section of obi

ōyoroi: samurai dress worn with full armor (Kamakura period)

pokkuri: lacquered *geta* for girls

rinzu: silk crepe
ro: leno weave silk gauze
rōketsu: batik
rokutsū gara: sixty percent patterned
rokutsū obi: sixty percent patterned obi
Ryukyu-*gasuri*: a splash pattern textile from Okinawa Pref.

saki-zome: textiles dyed before weaving
senui: back mid seam
sha: silk gauze
Shichigosan: celebration for children of seven, five and three
shima: stripe pattern
shiromuku: pure white bridal kimono
shitamae migoro: inner front panel
shitsuke: basting
shitsuke: discipline, training
sode: sleeve
sodeguchi: sleeve opening
sodeguchi fuki: lining at sleeve opening
sode haba: sleeve width
sodetake: sleeve depth
sodetsuke: armhole seam
sokutai: long trailing robe worn by court noble (Heian period)
some obi: dyed obi
suikan: short informal wear (Heian period)
sukiya-bukuro: small handbag for carrying things necessary for tea ceremony
sūo: warrior's robe (Muromachi period)
suru bunka: a culture that does
suso: hem
susomawashi: lining below collar end
susosen: hemline
susoyoke: half-slip

tabi: split-toed socks
taiko musubi: drum bow
tare: trail section
taresaki: end or edge of trail section
tateya musubi: standing arrow bow
te: short section

tegaki-zome: hand-painted design dyeing
tesaki: end or edge of short section
tobi Hachijō: brown Hachijō
tomoeri: over-collar
tsuke obi: ready-made obi
tsukesage: dyed pattern rising from hem to shoulder
tsukesage hōmongi: visiting kimono in *tsukesage* pattern
tsukesage komon: small design *tsukesage* pattern
tsukushi: device to hold floss when spinning *tsumugi*
tsumugi: hand-spun silk
tsumugu: to spin
tsuno-dashi-daiko musubi: drum bow with horns

uchikake: long outer robe, dating from Muromachi period
ume-gasane: shades of the plum blossom
ura eri: back of collar
ura yamabuki no uwagi: yellow and orange outer garment for winter and spring
ushiro haba: back width
ushiro migoro: back of body section
ushiro sode: back of sleeve
uwamae migoro: outer front panel

wakinui: side seam

ya no ji musubi: arrow bow
yoroi: armor
yoroi hitatare: general's ceremonial dress (Kamakura period)
yukata: unlined summer kimono
yuki: sleeve plus shoulder width
Yūzen: stencil resist dyeing technique and textile
Yūzen komon: small Yūzen design

zentsū obi: fully patterned obi
zōri: sandals

Index